Fenwick Island

DELAWARE

Fenwick Island

DELAWARE

A BRIEF HISTORY

Mary Pat Kyle

Charleston London

THE
History
PRESS

Published by The History Press
Charleston, SC 29403
www.historypress.net

Copyright © 2008 by Mary Pat Kyle
All rights reserved

All images are courtesy of the author unless otherwise noted.

Originally published 1995
The History Press edition 2008

Manufactured in the United Kingdom

ISBN 978.1.59629.505.6

Library of Congress CIP data applied for.

Contents

CONTENTS

Foreword

Fenwick Island is not actually an island…though at one time it was. It is a peninsula, with a wide ocean to one side and a modest bay to the other. Long before sun-worshiping families descended on the beach with towels and lotion in hand, Native Americans, pirates, English Lords, missionaries and perhaps even German U-boat seamen visited its shores. For a small town, Fenwick Island has an inordinate number of stories about its history—some factual and some fanciful. Mary Pat Kyle masterfully presents these old stories, along with a few updated ones, in this new revised edition of her history of Fenwick Island.

Fenwick Island, the land, is a barrier island created and continuously shaped by the ocean. Inlets come and go. Twelve-foot sand dunes emerge and then disappear. Fenwick Island, the community, is also shaped by the ocean. Early visitors came for the fresh sea air and redemptive powers of the sun and saltwater. The abundance of fish, shellfish and crabs made this a "Fisherman's Paradise." Very few came to Fenwick Island to work—this is a place to relax, refresh and replenish the soul.

Compared to many people referenced in the early sections of this book, I am a relative newcomer to Fenwick Island. My family was among those that participated in the first public land sale in 1942, when lots went for $100 to $250. My parents built our first house in 1953, a white cottage with green shutters, a porch in the front and an outdoor shower in the back. Back then, there were so few houses that we had an unspoiled view of every sunrise *and* every sunset.

I have witnessed many changes to this place over the years. Nor'easters washed away dunes, and nature and replenishment efforts brought them back. Hurricanes damaged homes, and we all got a little bit savvier about storm preparation. Developers dug canals and filled in land to create more lots for more homes on the bayside. Small seasonal cottages have slowly been replaced by year-round luxury homes (indoor showers, imagine that!). Seal Island continues to sink, and the number of summer visitors continues to increase.

Fenwick Island's appearance and character have changed from the "good old days" and it is easy to be nostalgic. However, progress is inevitable and new traditions bring new ways to enjoy what we have here, as the supplementary sections of this new edition point out. For instance, my children and grandchildren and I take great delight as charter

participants in the Fenwick Freeze polar bear swim, a recent and popular addition to the town social calendar.

Each of us holds Fenwick Island in high regard based on our own experiences. Knowing the history of Fenwick Island allows us to refine our ideas of what makes it so special. Mary Pat Kyle helps us to do that with this thorough and engaging walk through time.

Peter G. Frederick
Former Mayor
Fenwick Island, Delaware

Preface

For many years, bits and pieces of information about the Fenwick area have been published in the local newspapers and magazines. Books on the history of Delaware have provided little information on Fenwick, possibly on the assumption that not much has happened on the narrow stretch of barrier island. But, as we shall see, there was actually quite a lot going on. Inlets were created and closed, a long boundary dispute raged between Delaware and Maryland, Native Americans camped and fished, pirates roamed freely, a lighthouse was built, a salt industry flourished, a camp meeting was established, a resort proposal failed, German U-boats operated within sight of land and a town was created—all within, more or less, a five-mile radius of the lighthouse. It seems important to consolidate historical information about Fenwick in one document while there are observers still alive who recall the early years. That is the purpose of this collection of remembrances and observations.

The best keepers of Fenwick history have been Selbyville residents Paul and Dorothy Pepper. For years, the Peppers have been unfailingly generous in sharing their memories and records with journalists and historians. Dorothy Pepper has written *Folklore of Sussex County* and many historical articles; Paul Pepper has served as president of the Friends of Fenwick Island Lighthouse since its inception. Both have donated time and energy to the perpetuation of the history of the area. It is a privilege to be able to include here some of their recollections.

In addition to relying on verbal interviews with the Peppers and studies already in print about Fenwick, I have occasionally included my own observations gained since 1936. Some of these accounts were originally published in the *Delmarva News* and *The Whale* and are reprinted with permission of the publishers.

My sincere thanks to Nancy Haines and Mary Ann Negley for their expert assistance and to Dr. Ray Callahan and Dr. William Williams of the University of Delaware's Master of Arts in Liberal Studies program for their support and encouragement. Thanks also to John Rymer, for his technical support.

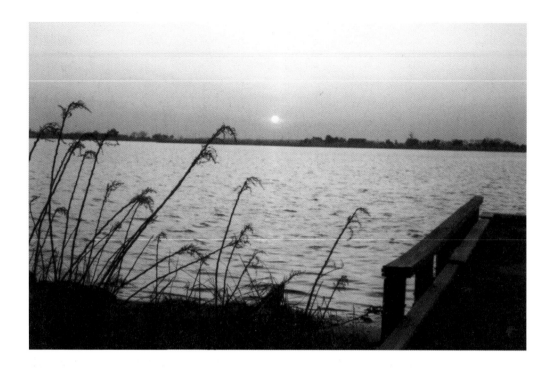

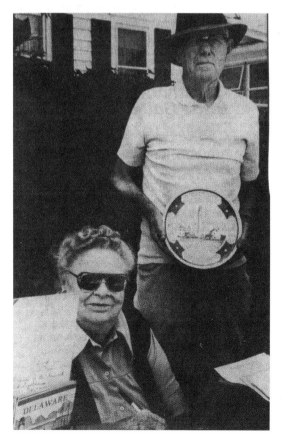

Above: Fenwick Island is located between the Atlantic Ocean and Little Assawoman Bay. As a result, we see the sun rise over the ocean and set over the bay. Assawoman is the Native American name for a "midway fishing stream." This photo shows the sun setting over Little Assawoman Bay.

Left: Paul and Dorothy Pepper were faithful keepers of the history of Fenwick. Dorothy, a retired schoolteacher, wrote numerous articles and a book, *Folklore of Sussex County*. Paul, who was a descendant of a Fenwick Island lighthouse keeper, was president of the Friends of the Lighthouse for many years. The Peppers lived in Selbyville in the winter, but returned to Fenwick every summer to operate Pepper's Cottages. Both are now deceased.

Introduction

Fenwick Island is classified by the U.S. Department of the Interior as

a peninsula, formerly an island, part of the barrier beach of Maryland and Delaware, extending from Ocean City Inlet, Maryland, north 12 miles to Sussex County, Delaware—38° 30' 30" N; 75° 03' 30" W.

A distinction is made by the Department of the Interior between "Fenwick Island, peninsula" and "Fenwick Island, resort community." The latter is described as "on the barrier bar between Little Assawoman Bay—at 38° 27' 20" N; 75° 03' 00" W." The more inclusive description of "Fenwick Island, the peninsula" obviously includes all of Ocean City and is still used in land record references.[1]

The history of Fenwick Island has been largely shaped by geological forces. Without the pounding sea and the resulting beach, a different story would have been written. Native Americans were attracted to the area because the harbor on the bay provided excellent fishing, and the proximity to the ocean usually provided a cooling breeze. However, the beach for many years was not a major attraction, except for a few hardy individuals like Zippy Lewis (see chapter six) and the lighthouse keepers. The desire to swim in the surf and relax in the sun is a relatively modern phenomenon. Improvements in roads, the development of better automobiles and the construction of the William P. Lane Bridge across the Chesapeake Bay all contributed to the development of the Fenwick area.

In the early days, because access was difficult, Fenwick was protected from development. Even from Selbyville, Fenwick was almost an all-day trip in the 1885 camp meeting era. Visitors came by wagon, crossing the "ditch" on the wooden bridge, which was built in 1892. Before that, they crossed the "ditch" by scow. It was not a journey to be undertaken lightly or often.

The isolation of Fenwick provided a dramatic contrast to the early development at Ocean City, which was connected to the mainland by the Wicomico and Pocomoke Rail Line as early as 1874. Boats were used to transport guests from the train station on the mainland until a bridge was built in 1876. By 1904, an ocean pier was built. The resort was brimming with houses and hotels.[2] Indeed, the history of Fenwick would have been

Fenwick Island is described by historian Dick Carter in *The History of Sussex County* as "the second most important point in the county, next only to Lewes, in significance. As a false cape, Fenwick played an essential role in establishing the present day boundaries of southern Delaware, which had it not been for the confusion surrounding Cape Henlopen's true location, would have been 20 miles to the north."

Although Fenwick was protected from early development by its isolation, Ocean City provided a dramatic contrast. The Wicomico and Poconoke operated a railroad as early as 1874. The first station was on the western side of the bay, and tourists came to the beach via boat. A later station in downtown Ocean City washed out in the storm of 1933.

vastly different if the Fenwick Island Land Company had been successful in an attempt to install a rail line down what is now Route 54 from Frankford.

Unlike Ocean City, Fenwick's development was more similar to that of its neighbor to the north, Bethany Beach. Bethany's first settlement also began in the late 1890s with a Christian Missionary Society camp meeting. The summer camp meeting was followed by a permanent development in 1900 and a town by 1901. Six Pittsburgh-area businessmen purchased Bethany Beach Improvement Company, and the first houses were built in 1903. The founders' goal was to establish a "permanent yearly seaside assembly for the Christian churches." At the turn of the century, it took two days to reach Bethany from Pittsburgh and one day from Washington. Unlike Fenwick, Bethany was not an island, but there were no roads to it either. Visitors came by train to Rehoboth, motored on a steamer down Rehoboth Canal, through the inland bays into the Assawoman Canal and finally reached the Loop Canal. No wonder they said:

> *Ocean City has a railroad*
> *Rehoboth two can claim;*
> *Bethany Beach has none at all,*
> *But we get there just the same.*[3]

Clearly, Fenwick's development lagged substantially behind Ocean City's and Bethany's. It appears that Ocean City's impetus was, even in those early days, commercially driven. Bethany's establishment was clearly entwined with the Christian Missionary Society. Although Fenwick had been host to the Methodist Camp Meeting, which introduced many visitors to the area, the Methodists were not involved in the hands-on development of Fenwick. People ended up coming to Fenwick just to enjoy the sea.

Part I
The Early Years (200,000,000 BC to AD 1600)

Assawoman

*I would sing
played I guitar
or ektar maybe
would suffice to please
the imagined Indian
(Assateague tribe?
Lenni Lenape?
Unca's Uncle?)
Who named this bay
before white men took
the land to work.*

—Roy Basler[4]

Here Today

In geological time, the Fenwick Island we know has existed for a very short period. Fortunately, geologists have devised methods to determine the nature of our past. By extracting core samples of the many layers of the earth's surface, they can discern what was marsh, what was field and what was ocean floor.

Geologists are able to state with certainty that the Atlantic Ocean did not exist until 200 million years ago. A shift of the continental plates caused the opening of the area that is now the Atlantic. Throughout time, the glaciers expanded, then retreated. These climatic changes affected the very presence of Delaware's shore as the shore area emerged and receded. The coast is estimated to have ranged from one hundred miles to the east to fifty miles to the west of its present location. Apparently, much of the state was underwater for perhaps a million years.

Dr. John C. Kraft observes:

> *Forty-five million years ago, the global climate was much warmer, allowing dense forests to exist within at least 200 miles of the North Pole. Subsequently, however, possibly before 10 million years ago, a great change in world climate began, and the Antarctic ice cap began to form. Since then, as the great North American and Eurasian ice sheets waxed and waned, the world has undergone a series of glacial cycles associated with relatively rapid rises and falls of ocean sea level. We believe that there were approximately seventeen warmer "interglacial" periods about like the present or a bit warmer, when there was a corresponding rise in sea level, interspersed with colder "glacial" periods in which more snow and ice accumulated, expanding the ice sheets and dramatically dropping sea level to as much as 600 feet below present.*[5]

All of these climatic changes had great impact on plant and animal life in southeastern Delaware. In a recently published study, Johan J. Groot reveals that between 25 million and 17 million years ago, when there were periods of a subtropical climate, palm trees grew and camels, elephants and small horses lived in Delaware.[6] Delaware Geological Survey's Scott Andres has discovered, through a study of fossils recently uncovered at a Del Dot excavation, that Delaware's climate 17 million years ago was like that of north Florida or southern Georgia.[7]

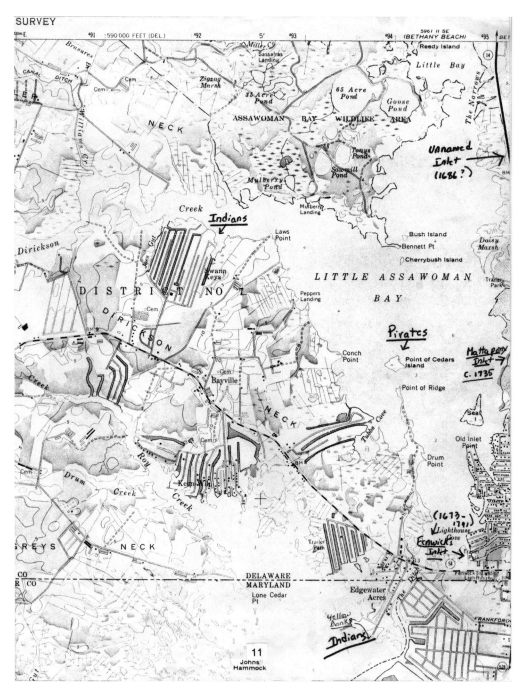

Little Assawoman Bay was a lively place. Originally, it was a closed bay, but legend has it that the Fenwick ditch was cut by a farmer who wanted to keep his cows from wandering from Fenwick. The "ditch" has deepened and widened and is now a navigable waterway. We know that the Native Americans summered here because of the artifacts that have been discovered. There were also many geological changes, as inlets opened up and closed with no jetties to keep them open. The Mattapany ("Landing Place" in Native American) Inlet is said to be the waterway used by pirates who sailed into the Assawoman Bay and stayed on what is now known as Cedar Island. The Mattapany Inlet is said to have been open until 1735.

Making a giant leap in time to around 17,000 BC, we find that the southern Delaware coast had moved seventy-five miles east of its present location. Colder temperatures and the Laurentide ice sheet to the north made the area habitable for polar, black and grizzly bears, as well as mastodons. But then the climate warmed again, melting the glaciers and the ice sheet. This melting and the consequent disposition of sediments created the present Atlantic Coast plain. As a result, sea level rose, flooding the southern Delaware coast. By 14,000 BC, the ocean had risen 440 feet. By 10,000 BC, the southern Delaware shoreline was ten to forty miles east of its present location.[8]

Much later, other dramatic changes took place. Not only did the coastline retreat farther west, but also inlets opened and closed, as they frequently do if they are not stabilized by jetties. In Fenwick, we know that the "Fenwick Inlet" existed at the southern end of Fenwick for the approximate period from 1673 to 1791. The "Mattapany Inlet," near what is now Indian Street, remained open until 1735.[9] A nearby peninsula is still referred to as "old Inlet Point." The Mattapany Inlet, which means "Landing Place," was reportedly widely used by pirates and Native Americans.[10]

The changing geology has been responsible for the evolution of Fenwick from the days when Native Americans came to fish to the present time, when visitors from everywhere come to enjoy the beach.

The First Native Americans

The first human inhabitants in Sussex County were American aborigines, descendants of those who crossed the Bering land bridge from Asia. The sea level was much lower then, making a crossing possible.[11] Or it is possible that they crossed the Bering Strait in small boats.[12] When the glaciers began to recede around eleven thousand years ago, vegetation began to appear, creating a vast grassland. The vegetation attracted buffalo, musk ox, mastodon and mammoth. The animals were followed by the Native American hunters, the first human settlers. The first white man would not see Delmarva for thousands of years.[13]

These Paleo-Indians, who were ancestors of the later tribesmen, are thought by Ronald A. Thomas to have arrived between five thousand and ten thousand years ago. Because they were hunters, these early residents lived in temporary campsites, following the grazing animals.[14] From around nine thousand to three thousand years ago, these archaic hunters roamed Delaware. They became more efficient in hunting and did not have to roam as far to find and kill game. They also learned to fish, to capture shellfish and to make knives, scrapers and stone axes.

Around two thousand years ago, Delaware's Native Americans learned that plants could be cultivated to ensure an adequate food supply. At about the same time, the bow and arrow came to Delmarva, changing hunting methods. Because projectile accuracy was improved, the hunter could kill from greater distances. Native Americans in Sussex also learned to trade their shell and mother-of-pearl ornaments with tribes a thousand miles away.[15]

To clarify the use of the term "Indian," it is useful to recall the explanation of Dr. Westlager, when he observed:

Why the term, which originated with Christopher Columbus in 1492, was perpetrated in the vocabularies of the later explorers, who by then knew they were not in India, defies explanation. Nevertheless, they called every native they saw anywhere in America an "Indian." Now we realize how inappropriate this misnomer actually was, because these native tribes spoke different languages and practiced entirely different customs.

Westlager noted, with regret, that many of the early descriptions of "Indians" were written by their conquerors, who "colored their account to suit their own purposes."[16]

The presence of Native Americans in southern Delaware was first acknowledged when Charles I granted the land to his friend Lord Baltimore on April 15, 1632. The charter of ownership refers to "the tract of land hitherto uncultivated—partly occupied by savages having no Knowledge of the Devine Being." Payment for the land was "yielding therefore unto us, our heirs and successors, two Indian arrows to be delivered to the Castle of Windsor every year."[17]

The Lenni-Lenape, meaning "original men" or "real men," settled mostly in northern Delaware. Their settlement near Lewes was possibly their most southern site. The Nanticokes, who lives in Maryland's lower eastern shore but later moved to Sussex County, were known to have had a large village near Laurel in the early colonial era. One group of Assateagues, which was driven out of Maryland, settled along the Indian River after having lived for a period on Dirickson Creek, just across the Little Assawoman Bay from Fenwick. These Assateagues were called the Indian River tribes.[18]

As the English settlers started to move northward from Jamestown in the 1640s and 1650s, they began to "purchase" land from the Native Americans, frequently paying them in rum. The Native Americans, who roamed so long at will, apparently did not understand that they were also relinquishing their hunting and fishing rights. Many problems were created by this misunderstanding of property ownership rights.[19]

It is difficult to determine, with certainty, where many of the Native American encampments were located. Because of changes in sea level and the resulting flooding, much of the evidence of very early Native American habitation may have been destroyed or covered with soil as part of the subsidence process. However, in some locations on Delmarva there is substantial evidence of earlier Native American activity. For example, near Cape Henlopen, twenty-foot mounds of shells were once visible from the sea—evidence of Native American use of the area. These mounds were also the source of some interesting arrowheads and pieces of pottery. Dr. Westlager reports that Francis Jordan, the archeologist who discovered the shell heaps, believes they predate 1600 because of the absence of any European objects in them.[20]

Although there is no proof that Native Americans lived in the Fenwick area, they were probably visitors, especially in the summers. The Nanticokes and Assateagues built their villages inland, but they were known to visit the coastal areas for the cooler breezes, much like the tourists of today. They used their summer visits to harvest shellfish and fish, which they dried for the winter.[21] The favored location for a Native American site was along the banks of a running stream, or preferably, at the intersection of two streams. Frequently, sites were within walking distance. Dorothy Pepper reports that the area formerly known as "Yellow Banks" was once an active site, and many arrowheads and tools were found there prior to the bulldozing for the development of Nantucket Point.

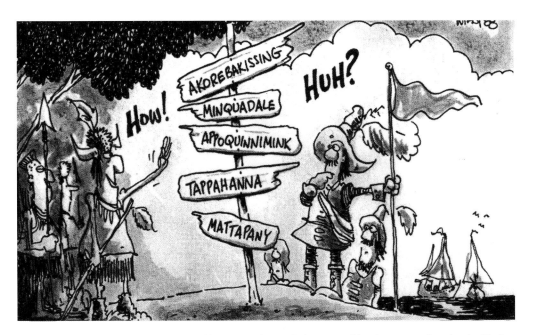

Chris Wildt says it all in this cartoon, which shows the confusion caused by the names given by the Native Americans to the local sites. The names were usually descriptive, according to John Tenny in his article on "Native Names."

The early residents of Delmarva have left an impressive legacy of geographic names, which we use today:[22]

Assawoman: midway fishing stream
Assateague: beyond the island or stream (inlet?) in the middle
Chesapeake: great shellfish bay
Choptank: stream that divides
Hockessin: place of many foxes
Mattapany: landing place
Nanticoke: shellfish eaten
Pocomoke: clam-fishing place
Raccoon: scraper or scratcher

The First White Man

Although it is generally agreed that Englishman Henry Hudson was the first European to discover Delaware Bay and that Captain John Smith was the first explorer of the Chesapeake, it is not certain who was the first non–Native American to explore Fenwick. Perhaps John Cabot was the first to see Fenwick when he glanced westward while sailing north along the mid-Atlantic coast in 1497. It is known also that Captain John Smith mapped (but not with great precision) the lands of Charles I that were later deeded to Lord Baltimore. Perhaps one of the first visitors to Fenwick was Colonel Henry Norwood. Abandoned after a mutiny by his crew in 1649, Norwood was rescued by the Native Americans who lived on Dirickson's Creek, and they guided him a hundred miles back to Virginia.

When the Dutch navigator Cornelius May (or Mey) sailed from Manhattan in 1616, he saw a cape from the New Jersey shore and named it for himself, Cape Cornelius. The confusion concerning Cape Henlopen and Cape Cornelius played a key role in the settlement of the longstanding dispute between the Pennsylvania Penns and the Maryland Calverts, which will be discussed in greater detail shortly.[23]

Samuel Godyn of the Dutch West India Company purchased a tract "extending northwards about 30 miles from Cape Henlopen to the Delaware River." After the Swedish settlers arrived in 1638, they attempted to buy the land from the false Cape Henlopen at Fenwick to the Schulkyll River. Apparently, the Native Americans had sold the same land to both the Dutch and Swedish colonists. At one point, a fort was proposed at Fenwick to protect the Swedish holdings, but it was never built.[24]

After the Dutch conquered the lands at New Sweden, they placed a brass plaque showing the arms of the Dutch West India Company on a tree near the Native American village of Assawoman. But in 1664, the Dutch surrendered to the English, which explains why the first Fenwick residents were English rather than Swedish or Dutch.

Enter Thomas Fenwick, a wealthy York planter. Fenwick's rights to the land at Fenwick Island came through a grant from Lord Baltimore in 1682. Fenwick, who originally settled in Maryland, never lived at the island named for him, but he did live in Sussex County for many years. He served as a justice of the peace, sheriff and register of wills. He died in Lewes in May 1708.[25]

The legend that Thomas Fenwick was thrown overboard from a pirate ship and swam to Fenwick Island is not widely accepted. More likely is the story that Fenwick's future son-in-law, William Fassett, did suffer that fate, and that he did indeed swim ashore, landing at Fenwick. Fassett later married Fenwick's daughter Mary and claimed Fenwick Island for himself, having earlier vowed that he would "become possessor of the island upon whose hospitable beach he had been cast."[26]

The Great Boundary Dispute

The Fenwick area was the subject of a long-lasting dispute between the Penns of Pennsylvania and the Calverts of Maryland. Each family claimed ownership, and it is easy to understand why. Charles I granted Maryland to Cecilus Calvert in 1632. Charles II granted Pennsylvania to William Penn in 1681 to repay a loan. The next year, the area that is present-day Delaware was added to Pennsylvania. The question was: Where did Maryland stop and Pennsylvania begin?

Although the original charter granted to Lord Baltimore in 1632 had defined the boundaries of Maryland, the property descriptions were, by necessity, based on landmarks and the geography of the area. The only map of the Delmarva region at the time was the one made by Captain John Smith in 1608, and this was vague in its descriptions.[27]

Part of the confusion concerning specific boundaries was caused by Dutch navigator Cornelius May. When May saw a cape from the New Jersey shore in 1612, he named it Cape Cornelius after himself. Later, when he saw another cape twenty miles south of Cape Cornelius, he named it Cape Hindlopen. However, the southern "cape" was not a cape at all, but rather a bulge in the coastline. When this fact was discovered some years later, "Cape Henlopen" was moved twenty miles north to describe the Cape Henlopen that we know today.

In 1680, because he assumed that the area was part of Maryland, Lord Baltimore granted a tract of land called "Fishing Harbor" to Colonel William Stevens, covering approximately the same area as Fenwick. "Fishing Harbor" probably referred to the Mattapany Inlet, located near Indian Street. In 1692, the plot named Fishing Harbor was conveyed to Thomas Fenwick.

In 1730, the king of England decided to give the Penn family the eastern half of the Delmarva Peninsula north of Cape Henlopen. But which Cape Henlopen—the one at Lewes or the one at Fenwick? The map submitted by the Calverts in 1732 contained the incorrect Cape Henlopen, thereby making it possible for Penn to claim land to the present Maryland-Delaware line. The southern boundary line was drawn some twenty miles south of where it should have been due to the confusion over the location of Cape Henlopen. Clearly, land that rightfully belonged to the Calverts ended up in the hands of the Penn family. Thus ended a very complicated and confusing period in the establishment of the Transpeninsular Line.[28]

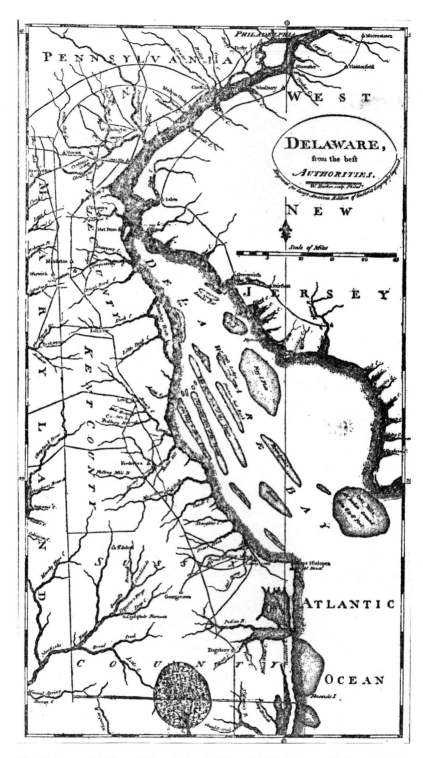

The Delaware Division of Historical and Cultural Affairs has provided us with this early map of Delaware, which clearly shows the protrusion that confused the early explorers who thought it was a cape. This caused the great boundary dispute.

The Transpeninsular Line

Much to the disgust of local historians, the line that separates Maryland from Delaware frequently has been called the Mason-Dixon Line. Until recently, there was a motel in Fenwick named the Mason-Dixon. There is now a Mason-Dixon Shopping Center in Selbyville. The proper designation for the east–west line is the Transpeninsular Line, and it is easy to see why that name was not used for commercial establishments (the Transpeninsular Motel?).

The Transpeninsular Line, which was surveyed in 1750–51, begins in Fenwick. The marker at the lighthouse is "the oldest standing man-made object on the coast between Indian River and Ocean City," according to Dick Carter. The marker, which originally came over from England as ballast on the ship *Betsy Lloyd*, was quarried on the Isle of Portland. It displays the coat of arms of Lord Baltimore and the Calvert family of Maryland on the south side, and on the north side it shows the coat of arms of the Penn family of Pennsylvania. Surveyors John Weston and William Parsons represented the

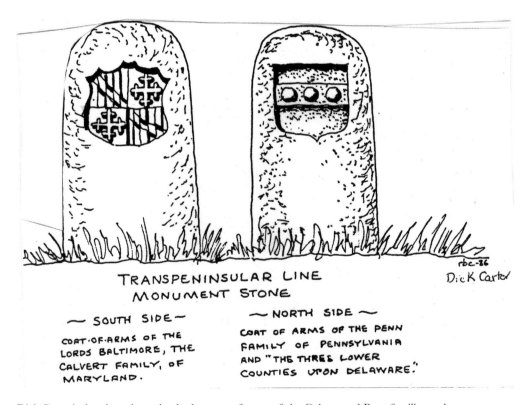

TRANSPENINSULAR LINE
MONUMENT STONE

rbc-86
Dick Carter

~ SOUTH SIDE ~

COAT·OF·ARMS OF THE
LORDS BALTIMORE, THE
CALVERT FAMILY, OF
MARYLAND.

~ NORTH SIDE ~

COAT OF ARMS OF THE PENN
FAMILY OF PENNSYLVANIA
AND "THE THREE LOWER
COUNTIES UPON DELAWARE."

Dick Carter's drawings show clearly the coats of arms of the Calvert and Penn families at the Transpeninsular Line. This line extends from the lighthouse westward to the Maryland line, with markers every five miles. The markers at the lighthouse and in Delmar are clearly visible; some of the others are hidden in the woods. The Transpeninsular Line marks the southern boundary of Delaware and bisects the Mason-Dixon Line in Delmar.

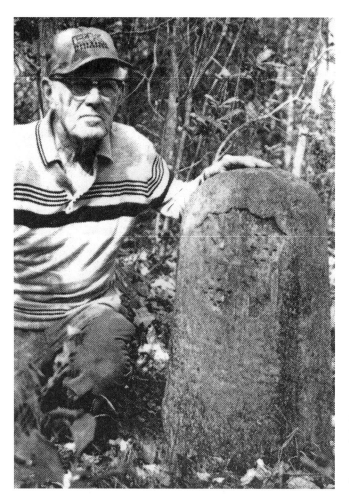

Paul Pepper kneels beside the Transpeninsular Line five-mile marker located in a thick woods west of Fenwick Island. The marker clearly shows the Calvert coat of arms and the round crown distinctive of the Transpeninsular Line stones.

Penn family, and John Emory and Thomas Jones of Maryland represented the Calvert family in determining the boundary.

The Transpeninsular Line runs sixty-nine miles due west across Delmarva to Taylor's Island. Markers were placed every five miles, except for the one that should have been placed in the Pocomoke River. Although the markers were probably identical at the time of their placement, they are in varying stages of deterioration. The first stone at Fenwick is remarkably well-preserved. The second is in a wooded area five miles from Fenwick and has eroded considerably. The third is in Selbyville. Twenty miles from Fenwick is the marker at Line Methodist Church on Route 54, southwest of Gumboro. The southwest corner marker is in Delmar. It is here that the Transpeninsular Line meets the north–south line drawn by the English surveyors Charles Mason and Jeremiah Dixon in 1760. The Transpenisular Line represents the final determination of the southern boundary that was disputed by the Penns and the Calverts for a hundred years.[29]

Yo Ho Ho

Cedar Island, Ahoy!

While the Penns and the Calverts were disputing ownership of the land in the Fenwick region, pirates were contesting property rights on the sea. In Delaware, pirates were not just storybook characters; they were real live plunderers who made life miserable for the local sea captains between 1650 and 1750. According to local old-timer D.J. Long, pirates used Cedar Island—small and now shrinking—in Little Assawoman Bay as headquarters. Reportedly, pirates buried money there. Long wrote:

> *It was said that there were lots of holes in which pirates used to bury their money. Folks used to go digging there. I have also heard that when they were digging, they could hear ghostly sounds, as of boats coming in with sails snapping and cracking in the wind. So folks said the place was haunted.*[30]

Developers of the Fenwick Island Land Company reported having discovered some pirate cannonballs on the Fenwick beach.[31]

Dorothy Pepper relates a pirate story involving Captain Jedediah Evans of Roxana. Evans was a schooner captain who was once boarded by pirates. Captain Evans greeted the invaders and treated them with courtesy. Apparently disarmed by his friendly manner, they began to leave, but the captain insisted that the pirates join him for supper and spend the night. Before breakfast, Captain Evans invited them to join his crew in morning prayer. The pirates departed and never bothered his ship again.[32]

A less friendly pirate was Captain Louis Guillar, who operated off the Delaware and Maryland coast between 1698 and 1700. He made Pirate Island in the Sinepuxent Bay, south of Fenwick, his headquarters. In June 1698, Guillar and first mate Pieter Hoogly pursued the *Maid of Perth*, which was headed for Philadelphia. The ship was carrying china, ironware and twenty-seven indentured Scots. Guillar and his crew removed coin silver, ship's gear, sails and guns and ordered the crew of the *Maid of Perth* into lifeboats. They then sank the ship. Later, in 1698, Guillar pursued the *Santo Paulo*, a Portuguese ship, off the Delaware coast. The pirates fired at the *Santo Paulo* for hours until its captain grounded the burning ship in shallow water. Unbeknownst to Guillar, the *Santo Paulo* carried a fortune in silver ingots. These sank with the ship, and a few have since been found offshore.[33]

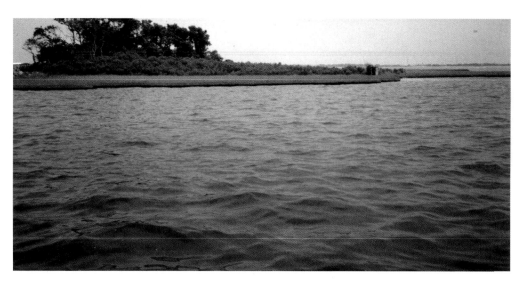

Cedar Island, rumored to have been a pirate hide-out, is still here—but sinking!

The infamous Captain Kidd was said to have visited Cape Henlopen in 1700. Blackbeard was rumored to have been in the Fenwick area as well. (According to Dorothy Pepper, Blackbeard tied fourteen small ribbons on his beard—one for each of his wives.)[34]

Part II
1800–1899

The Yacht Club has
not a single yacht.
Seal Island has
really no seals.
The City Hall
so called is not.
But the Line begins
(Mason-Dixon)
and the only Lighthouse
between Cape May
and far Cape Charles
blinks all night
its poem HERE
Is HERE

—Roy Basler

Zippy Lewis

Hard Bargainer

Delmarva's original beachcomber, Zippy Lewis, surely would never recognize her old stomping ground in Ocean City with its high-rises and shops. When Zippy lived in the area near what is now the Carousel Hotel, there was nothing there but beach grass. Somehow she was counted in the 1850 census. It must have been an adventurous census taker who visited the beach area then because the first known structure to have been built in Ocean City was not erected until 1869.

Zippy was a real person, no doubt about that, but no one knows how many of the stories about her are true and how many are only legend. The creek near the Carousel is still called "Zippy's Creek." Born in Delaware around 1800, Zippy married Jonathan B. Lewis, who was a Williamsville native. They settled south of the Fenwick Lighthouse and produced five children: Jacob, Jonathan B., George W., Mary E. and Ginsey C. Their house was built with timbers from wrecked ships and furnished with other "finds." Jonathan Lewis disappeared at sea between 1846 and 1850. Rumors circulated that, after Jonathan's demise, Zippy took in a man every winter, but she lived alone in the summer when the living was easier.[35]

Local resident D.J. Long wrote of having visited her on the beach in 1872, approximately two miles south of Fenwick.

> *We found a widow, Zippy Lewis, her skin browned by the sun. We had dinner with her. It is reported that she has a lot of beach money buried on the island somewhere.*[36]

Zippy probably did have a stash of coins. She was quick to collect anything that could be profitable. In addition to coins, she is said to have collected a large number of cowhides that had washed up on the shore. She sold these to a local tanner for ten cents. She frequently traded items she could not use with merchants in Berlin, Maryland.

Apparently, Worcester County, Maryland officials heard of her profitable activities and appointed an official "wreck master" to salvage washed-up treasure for the county. It is said that Zippy outsmarted or outlasted the wreck master most of the time, once even lying on a sea chest all night until the wreck master gave up and went home. She found it first, she claimed.

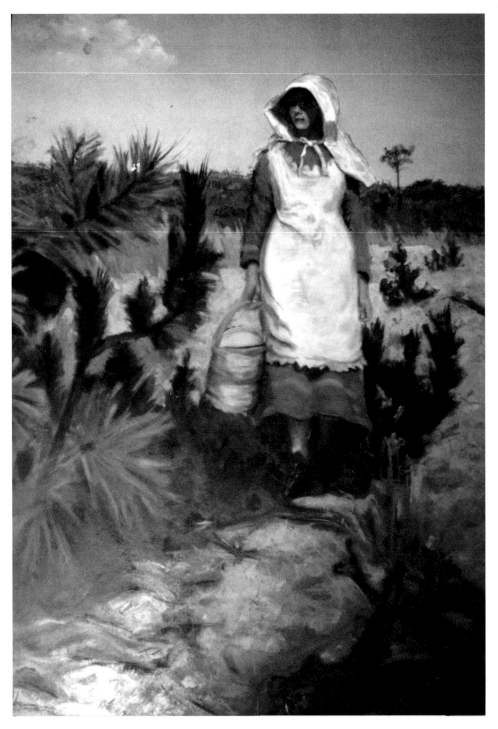

Zippy Lewis was one of the early residents of this area. Born around 1800, she managed to subsist on coins and other treasures that washed ashore from the many shipwrecks. She was known as a hard bargainer, trading some of her finds with merchants in Berlin. We know she is not just another legend, for she was counted in the 1850 census. This portrait, by David Bunting, hangs in the Zippy Lewis Lounge at the Dunes Manor Hotel in Ocean City.

Zippy's land patents, named Hard Bargain and Hard Fortune, were for seventy acres, some of which she farmed. Sue Hurley writes:

> *Zippy Lewis' inventory of goods and chattels dated June 21, 1879 offers clues to her way of life. Furniture included three beds, a table and six chairs; queensware and assorted pans, baskets and buckets; a spinning wheel and loom; wool, raw cotton and cotton yarn; an extraordinary number of sheets, quilts and counterpanes; pitchfork, scythe, as well as garden tools; a harrow and corn in the ground; a yoke of oxen and ox-cart; a bull, nine cows and calves. The cattle comprised two-thirds of the value of Zippy's estate. Only $2.50 was listed as "cash on hand."*
>
> *Zipporah Lewis wrote her will on Nov. 7, 1877, which was filed at the Snow Hill Court House on June 17, 1879. She left a dollar to each of her sons or their heirs and her property to her daughters. Ginsey inherited the portion of land with the house that stood near the beach until it burned nearly 60 years after Zippy's death.*[37]

Fenwick Island Lighthouse

Increasing numbers of wrecks near the shoals six miles east of Fenwick caused the U.S. Lighthouse Board to recommend the construction of a lighthouse. Congress agreed and authorized the project in 1856. The highest point in the area was chosen for the site, and $50.00 was paid to Mary C. Hall for the property in 1858. Later in the same year, construction began on the lighthouse and a keeper's house to the east. By 1859, both buildings were ready. The lighthouse was turned on on August 1, 1859. Its light guided mariners until it was turned off in World War II to prevent silhouetting American ships that were trying to avoid German U-boats. The lighthouse and the house cost $23,748.96.[38]

The lighthouse is eighty-seven feet tall. The original light was visible for fifteen miles. The illuminating apparatus was a "a third order of the system of Fresnel," according to the *Notice to Mariners* issued at the time of completion. The original lamp burned whale oil. In 1882, it was changed to a mineral lamp, and it was finally electrified in 1899.

The Fresnel lens was named for its inventor, Augustin Fresnel, who designed lenses that, by 1823, "collected and focused the light rays into a horizontal beam far more efficiently than the reflector system," according to Dudley White. These lenses are sometimes referred to as the "French system."[39]

The Keepers

The first keeper's house, just east of the lighthouse, was occupied by two families. The keeper and his family lived downstairs and the assistant keeper lived upstairs. Water was stored in a cistern in the basement. As in Bermuda, the rain was collected from the roof. The members of the keeper's family could anticipate a life of isolation because reaching even the closest town was no easy matter. Because there was no bridge over the "ditch" that separated Fenwick from the land to the west, they had to cross the ditch by boat. The keeper's children then had to walk a mile and a half to the one-room school at Bayville. The Peppers note:

NOTICE TO MARINERS.

NEW LIGHT-HOUSE
AT
FENWICKS ISLAND, DELAWARE,

Twenty miles to the southward of Cape Henlopen,

ATLANTIC COAST.

Fixed Light varied by flashes—Interval between the flashes two minutes.

Notice is hereby given that the new tower at Fenwicks Island, Delaware, is finished, and that a light will be exhibited therefrom for the first time at sunset on the evening of Monday, the first day of August next, and will be kept burning during that night, and every night thereafter, from sunset to sunrise. The tower is built of brick, is 75 feet high, and is surmounted by a lantern 10 feet high.

The watch room and lantern are painted black, the tower and keepers' dwelling white.

The illuminating apparatus is of the third order of the system of Fresnel, and will show a fixed white light varied by a bright flash every two minutes.

The focal plane is 86 feet above the level of the sea, and the light should be visible in ordinary states of the atmosphere 15 nautical miles.

The approximate position of the light-house, as deduced from the Coast Survey charts, is—

Latitude, 38° 27' 00" North.
Longitude, 75° 03' 30" West.

By order of the Light-house Board:

W. F. RAYNOLDS,
Captain Corps Top. Engineers.

PHILADELPHIA, PA.,
October 29, 1858.

26

This note to mariners was issued by the U.S. Army Corps of Engineers in 1859 to inform sailors about a new lighthouse that would be visible for fifteen nautical miles and would be located at Fenwick.

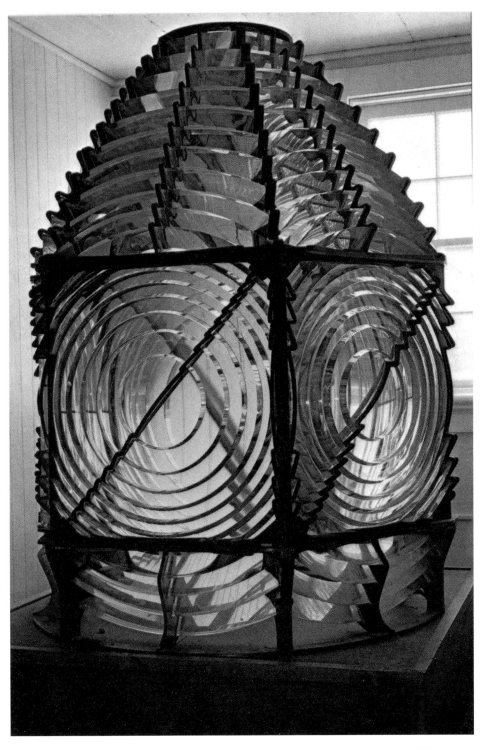

Pictured is a third-order lens, as displayed at the Chesapeake Bay Maritime Museum. This is similar to the Fenwick Island Lighthouse lens. It is easy to see why the keepers had a full-time job in keeping the lens free from the soot generated by the whale oil lamps.

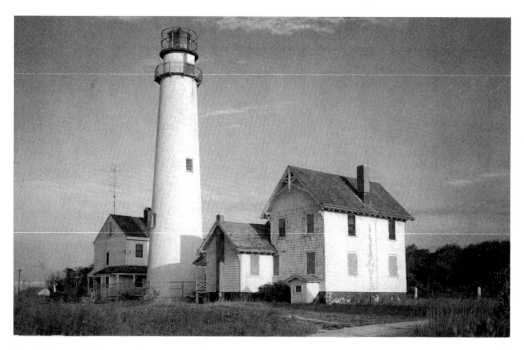

Fenwick Island Lighthouse.

When the family decided to visit their relatives on the mainland, they would drive a horse and carriage out onto a small, flat scow, and pull the scow across Fenwick ditch with a rope. Then they would drive to Selbyville, where they would catch a train to Georgetown.

The first bridge over the "ditch" was built by residents in 1880, but it did not survive the strong current and collapsed. In 1892, a new wooden pile drawbridge was built. A third was built in 1934, and the current bridge was built in 1958.

Paul Pepper's great-grandfather, David M. Warrington, was appointed the third keeper of the lighthouse on July 26, 1868. His family occupied the first floor, his son-in-law, Edward Pepper (Paul's grandfather), was the assistant keeper and lived on the second floor. Paul Pepper's father was born there.

It became apparent that an additional house was needed, so in 1881 a second house was built to the west of the light. The keeper then lived in the newer house, leaving the older structure for the assistant keeper.

Life for the keepers was basic. In addition to tending the lights, they raised vegetables and canned for the winter. Pigs were a necessity, and fish supplemented the pork diet. Dorothy Pepper reports that there were many foxes in the area, and a popular pastime was playing with the little foxes, which were quite tame. The keepers were paid from $400 to $600 a year until 1899, when they received a raise to $825.

The first lighthouse keeper was John Smith (1859–61). Other early keepers were:

W.R. Hall (1861–68)
David M. Warrington (1868–74; 1874–76)
James H. Bell (1874; 1876–declined)
Samuel W. Vaughn (1876–appointment revoked)
John A. Gun (1876–80)
John D. Bennett (1880–1907)
Samuel Super (1907–10)

The last keeper was Mr. Charles L. Gray.[40] However, in 1979, the United States determined that newer navigational aids made the lighthouse obsolete. It was closed and stripped of its equipment. The valuable Fresnel lens was taken to Governor's Island, New York, where it was stored in the office of the commandant of the Coast Guard.

The local citizenry was outraged. People feared the possible destruction of the lighthouse or its sale for commercial use. A letter-writing campaign began. Delaware's Senators William Roth and Joseph Biden and then Congressman Tom Evans became involved both in preservation efforts and in trying to have the lens returned. Eventually, their efforts were successful. The lighthouse was deeded to the Friends of the Lighthouse, and the Coast Guard, assisted by Dick Carter and Paul Pepper, reinstalled the lens.

Today, the Friends of the Lighthouse, under the leadership of Paul Pepper, is responsible for the maintenance of the building. Painting the lighthouse is no easy job, and painters who would be willing to swing out from the top of the light in a barrel and whitewash it for $5 (as was paid in the early days) are hard to find. Recent costs have been close to $12,000.

The Friends of the Lighthouse hold open house at the lighthouse twice monthly in the summer months with volunteers on-hand to greet visitors and give them a little history lesson.

Salt-Making

S alt-making was one of the few early commercial enterprises at Fenwick, where farming was the most typical early occupation. In the late 1700s and 1800s, the ocean would periodically wash over at least parts of Fenwick during storms, just as it does today. As a result, the water beneath the sand in some locations collected a heavier concentration of salt. Water in a good pothole at Fenwick averaged 8.37 percent salt, compared to the standard 2.79 percent saltwater.[41]

James and Jacob Brasure, who lived in Fenwick, were the first to try salt-making. First, a suitable location was decided upon, and then holes were dug and water removed. The water was placed in very large pots and boiled away. Salt was left in the bottom of the pot. According to Paul and Dorothy Pepper:

> The salt was hauled by ox-cart to Sandy Landing, on the south side of Indian River, to Millsboro. In later years, it was taken to Frederica, which was served by steamboats. From those points it was shipped by boat to Philadelphia, where it sold for $2.00 per bushel or $6.00 a barrel.

The Peppers estimate that salt-making was probably discontinued around 1875, after numerous other salt deposits had been discovered elsewhere. One of the pots that was used in the local salt-making process has been returned to the Fenwick Island Lighthouse, where it is on display. It was owned by Mr. and Mrs. G.L. Bennett. Mr. Bennett is a descendant of G. Luther Bennett, one of the salt-makers. The salt pot, which weights over five hundred pounds, was used to water livestock until its return. In addition to Luther Bennett, John Bennett, Henry J. Williams and Stephen Ellis's family worked on salt-making at Fenwick in the 1880s. Salt was also made on the flats beyond the Henlopen Lighthouse, some twenty miles north of Fenwick.

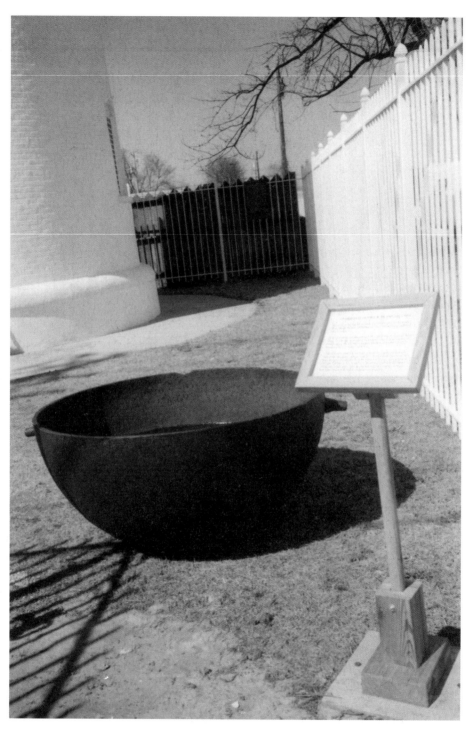

This is an authentic pot used for making salt in Fenwick. It was returned to the Fenwick Lighthouse by George Bennett III, descendent of salt maker Luther Bennett. Sea water was boiled in this five-hundred-pound vessel until it evaporated. The remaining salt was collected and sold in Philadelphia, having traveled by ox cart to Millsboro, where it was placed on a steamboat. Salt making was an active business in the late 1800s.

The U.S. Life-Saving Service

For whatever reason—meteorological, geographical or human error—the Delaware coast has always been a ship graveyard. George Hurley states that there were three hundred wrecks off the Delaware coast from 1875 to 1914 alone. The large number of wrecks off the Fenwick shore was probably due principally to the Fenwick Island Shoals, a ridge of sand 6.5 miles east of Fenwick. The shoals were the reason that the Fenwick Island Lighthouse was ordered in 1856, and they still represent a danger, now marked by flashing buoys. The numerous wrecks soon became a hazard in themselves, and this was an additional reason for the creation of the U.S. Life-Saving Service in 1875. In an effort to preserve the lives of the wreck victims, lifesaving stations were erected along the coast and manned with personnel trained in surf rescue.

Lifesaving stations were placed north and south of Fenwick. Fenwick's station was built in 1891, one and a half miles north of the Maryland line. Having been commissioned well after the peak shipwreck years, the Fenwick Station never saw as much action as the Ocean City Station, which was built in 1878. The Ocean City station is now a museum. The Fenwick station was taken out of service after the decline in wrecks, which may have been attributable to the increased use of steamships that had better navigational control. The Fenwick station was sold to private owners, who moved it to Ocean City, where it was used as a motel. The first keepers of the Fenwick Life-Saving Station were Stratton Schelliger (1891–92), John H. Long (1894–1903) and John S. Pruitt (1904–14).

The Isle of Wight station was built four miles south of Fenwick in 1889, approximately where Eighty-third Street is today. It was decommissioned in 1936. Later, it became a bar. After it was damaged extensively in the 1962 storm, it was burned at the owner's request. The U.S. Life-Saving Service station just north of the Indian River Inlet still exists. It has been converted to a museum and is open to the public.

On the Eastern Shore of Maryland, Delaware and Virginia, the U.S. Life-Saving Service operated from 1875 to 1914. During that time, it saved 7,501 shipwrecked people.[42] Visitors can visit the U.S. Life-Saving Museum at the inlet in Ocean City to view the history, not only of the U.S. Life-Saving Service, but of Ocean City as well.

The old lifesaving station north of the Indian River Inlet has been out of commission for many years. It became headquarters for the Beach Preservation Section of DNREC, but was renovated with a state grant and private funds. It is now a museum and has been furnished appropriately to show the living quarters of a surfman on duty there. Frequently, special programs are held to demonstrate the lifesaving techniques used by the surfmen. It is open to the public.

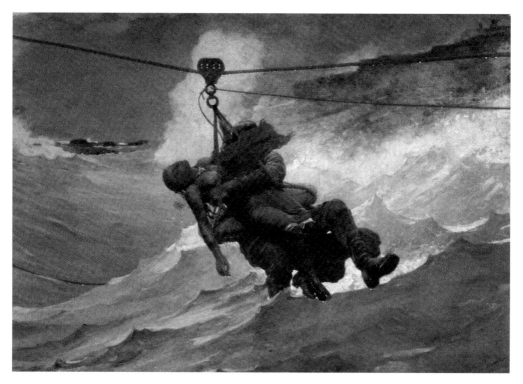

Winslow Homer's oil painting, *The Life Line* (1884), demonstrates a sea rescue where a line was "shot" to a distressed vessel and passengers were helped to shore by the surfmen.

Fenwick Island Land Company and the "Ditch"

If the Fenwick Island Land Company and Fenwick Gunning Club Preserve had been a successful venture, today's Fenwick would be a vastly different place. In 1894, the investors envisioned a "Fenwick Island City." In promoting their new development, they described Fenwick as

> one of the nearest points on the coast to the Gulfstream, making its climate balmy and healthful. The prevailing wind is from the south and the climate is always moderate. During the hottest part of the summer, the thermometer very seldom rises into the 80's, and then, but for an hour or so. One of the most remarkable points in favor of the climate is its influence on throat troubles. Mild cases of chronic catarrh and hay fever disappear entirely, while the beneficial effects upon the worst cases is only short of marvelous. Typhoid fever and malarial fever are unknown.

The prospectus further claimed that "the water is at the right temperature and there is no dangerous undertow. The beach is like velvet. There are no stones or shells."[43] (It should be noted that there were no "truth-in-advertising" statutes in those days.)

The Fenwick Island Land Company and Fenwick Gunning Club Preserve had offices in Wilmington and Baltimore. George F. Taylor was the president and William M. Rosenberger was secretary and treasurer. It proposed selling lots in eight hundred acres on either side of what it incorrectly termed the "Mason-Dixon" line. (We know that the correct name for the boundary is the Transpeninsular Line.) To improve hunting, the developers suggested filling in the Fenwick ditch. They claimed that this gateway to the ocean had destroyed the wild celery that formerly grew in abundance and attracted canvasback ducks. They planned to erect a "commodious gunner's clubhouse" within Fenwick Island City. Nine acres were set aside for a camp grove. Other plans included building an "electric railway" from Frankford to Fenwick and later a hotel and boardwalk on the Fenwick beach.

Lot prices ranged from $50 to $500, cash only. The oceanfront lots were twenty-five and fifty feet wide and two hundred feet deep. Reserved on the oceanfront were several blocks for oceanfront hotels. Part of the hotel deed restriction was that any hotel must contain one hundred rooms. The prospectus concluded:

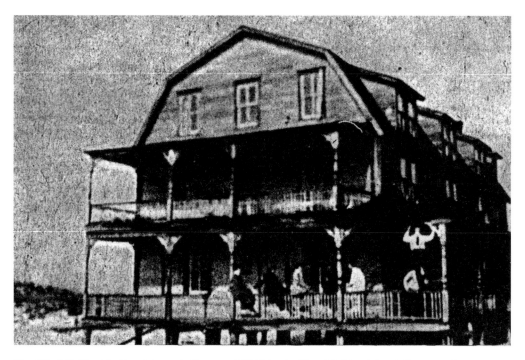

The Windrift Hotel in Fenwick was built around 1900 by the Fenwick Island Land Company. It was situated near the proposed railroad line. Never profitable, it was first sold to the Kirk family. In 1922, it was bought by a group of local residents, including Vollie Murray, William Law, Roland Buell, Lee Stevens, Elwood Cook, Raymond Morris, Clayton Bunting and Russell Hill. It was subsequently used as a summer retreat for the owners and others until it was destroyed in a coastal storm in the 1940s.

It seems as if nature, knowing how tired human beings would become in the great hurrying of the city, had specially provided this place as a restful haven, where persons of glamour and refinement could dwell almost within sight of the glimmering lights of the great cities and far enough to be free from the artificial existence of the town and its fever-haunted atmosphere.[44]

For whatever reason, the land company was not successful in creating Fenwick Island City. Probably the failure of the railroad to build tracks from Selbyville to Fenwick was instrumental. However, some lots were sold and a hotel was built—but not with one hundred rooms.

The Ditch

The Fenwick "ditch" is really not a ditch, but more like a flowing saltwater river. It connects Little Assawoman Bay with Big Assawoman Bay and is crossed by the present Route 54 bridge. The "ditch" is not a natural stream. It was said to have been cut during the late eighteenth century to prevent the cattle being raised at Fenwick from wandering

away. However, in subsequent years, the ditch became wider and wider, and the currents began to flow with increasing strength from Little Assawoman into Big Assawoman. There was speculation that this flow was instrumental in the filling in of the Mattapany Inlet, which was used by pirates and, later, as a harbor for shell fishermen. Residents complained to the General Assembly in 1800 that the ditch should be filled in, but no action was taken.

Fenwick Camp Meeting

Fenwick's first summer settlement began with a camp meeting. According to D.J. Long, until the camp was built, there were few houses in the Fenwick area. The proximity of surf and sand made Fenwick a logical choice for a camp for inland residents. Like the camps at Bethany and Rehoboth, the Fenwick Meeting was founded for religious reasons by D.J. Long, Ananias Derickson, Isaac Derickson, Edward Pepper, John Bennett, Captain John Long and Elisha Dukes. The first camp meeting was held in August 1898 in a grove of oak trees about three hundred yards from the ocean. Local historian Dorothy Pepper, whose family had a "tent" at the camp, reports that the camp was located on what is now 141st Street, near Phillips Restaurant in North Ocean City. The trees are still visible.

Approximately fifty cottages or wooden "tents" were built around a circle, with the tabernacle in the middle. The "tents" were built so that the entire end could be raised for ventilation. Dirt floors were covered with straw. Lofts were built for sleeping and the shed kitchens were in the rear. Mattresses were made from corn shucks and assembled at shuck-tearing parties, where the softer part of the corn shuck was shredded and stuffed into ticking cases.

The tabernacle housed an old organ and a small stage, where the choir sat. Penny candy and nickel ice cream cones were sold at the confectionery stall, which was a concession put out for bids each year. Usually, Cory Evans, father of "Crab House" founder Cashar Evans, was the successful bidder. There was also a stall for horses and mules. A boarding tent provided food at almost any time, and summer visitors rented rooms there during the camp meetings.

On a typical day at camp meeting, there were usually three services. The morning service was devoted largely to hymn singing, followed by a short sermon. Dorothy Pepper remembers that the songbook cost twenty-five cents. "We couldn't wait to attend services and sing," she recalls. There were also afternoon and evening services. Before the last session, the young people would "promenade" around the grounds. Occasionally, it was difficult to persuade the young folks to suspend this activity and come to the service. Frequently there was a bonfire on the beach and more singing. Sometimes, white and sweet potatoes were roasted in the fire.

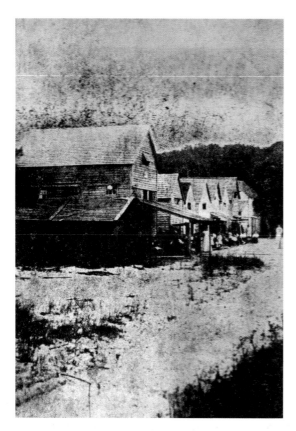

Left: Lea Avenue (141st Street) in North Ocean City was the site of the early Fenwick Camp Meeting. This photo was taken somewhat later.

Below: Camp meeting around the turn of the century.

Getting to the beach meant walking on a long boardwalk over the marsh and cranberry bogs. On occasion, the cranberries were picked to take home.

Even though most of the families were locals, it still took them all day to reach the meeting ground. Most people came by wagon and brought their own food. Live chickens were transported in their coops. Flour was brought in bags. Plenty of potatoes and seasonal vegetables, such as tomatoes and beans, were standard fare. As Mrs. Pepper remembers, for two weeks in August visitors had a chance to sing, hear interesting sermons, socialize and occasionally do a little flirting.

Part III
1900–Present

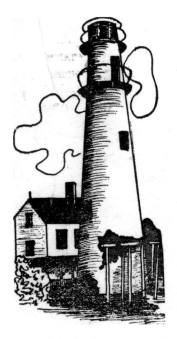

A Fenwick Island poem postcard.

DELAWARE'S FENWICK ISLAND BEACH

There are many spots of beauty at the lakes and by the sea;
But the Ocean Isle of Fenwick always seems the best to me.
Nestled off the coast of Delmar, with the silv'ry bay between.
Its sand-dunes are as picturesque as eyes of man have seen.

Its quaint historic lighthouse on the Mason-Dixon line—
Where Maryland meets Delaware near by the surging brine—
Throws its beams through blackest darkness to ships far out at sea
Flashing light to guide the sailors as they serve humanity.

The cottages have coolness from the ocean broad and wide,
While the rhythmic waves lash music with the ceaseless surging tide
The long stretch of sand-beach, as fine as sugar sweet,
Greets one's view each passing moment with a beauty most replete

The balmy air invigorates, the sun shines clear and bright;
The shore-lines of bay and ocean fill one's heart with great delight
The cottagers are friendly and accommodating, too,
As they live in peace and quietness, and expect the same from you

The seafowl and the beach birds and the dolphins leaping high,
Add interest to the setting for every passer-by.
Upon this "Elysium Charming" such perfect peace abides,
I think I'll drive my stakes here, for "Here is Paradise."

R. C. HELFENSTEIN.

Life at Fenwick in the '30s

By the early 1920s, Fenwick's best-kept secret (that it was possible to build on state land in north Fenwick without being ejected) was discovered by an ever-increasing number of beach lovers. The early cottages were very simple, with no heating or plumbing, because there was no electricity. They were all similar in construction, with a porch on the front, kitchen on the back, first-floor combination living-dining room, one large room upstairs and a privy in the backyard. The large, open bedroom enabled sleepers to benefit from any breeze that might be stirring. The bedroom was adjusted for coed occupancy by hanging a blanket from a clothesline. Oddly, although all the cottages were on state land, the "squatters" clustered their houses close together, with little space between them.

There were three distinct sections of Fenwick. The section south of the Maryland-Delaware line was called, not surprisingly, "Maryland Beach." A settlement on the Delaware side was called "Delaware Beach," and the section now known as the incorporated area was called "Pittsburgh Beach" because some of the early cottage builders were from Pittsburgh. (Having noted previously that Bethany's first settlers were also from Pittsburgh, one wonders what summers in Pittsburgh were like!) Each section had its own personality. Maryland Beach was the liveliest with Parson's store, which had tables and a jukebox. Delaware Beach was mostly residential, and Pittsburgh Beach was totally so.

There was no grocery store at Pittsburgh Beach, but Laura and Jimmy Clark were Fenwick's first entrepreneurs. Laura drove her balloon-tired station wagon up the beach, stopping at each cottage to take orders. Later, she would return with the groceries. Nothing exotic, of course, but the service was very convenient for obtaining staples. Jimmy Clark, who was later to be the first magistrate at Fenwick, delivered ice from the beach several times a week. The Clarks later operated a small store and a homemade miniature golf course at the northeast corner of Coastal Highway and Dagsboro Street.

Fenwick in the 1930s would not have been attractive to everyone. Many folks in search of a vacation would not have been interested in pumping water from a hand pump, driving a dozen miles to obtain ice for the icebox, using kerosene to light the oil lamps and kitchen stove and becoming accustomed to a privy. With no electricity, the only contact

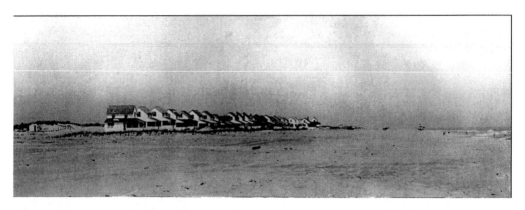

Fenwick Island Cottages, September 4, 1938. *Photo courtesy of Delaware State Archives, Purnell Collection, L-162.*

This postcard from the Delaware State Archives reminds us that the roads from Fenwick to Bethany were nonexistent. If you were in a hurry and didn't want to drive inland, you let some air out of your tires and drove up the beach.

with the real world was a battery-powered radio. Unlike today's compact batteries, the 1930s model was the size of a breadbox, but no one was really too interested in what was happening in the "real world" anyway. The hardy band of early summer residents loved it. The inconveniences of primitive living were more than compensated for by the uncrowded wide beaches, leisurely pace and excellent fishing.

When you wanted water, you placed a "point" on a pipe and pounded it into the sand until you hit water. When you had garbage to dispose of, you buried it. Trash was burned. "Backhouses" were at the rear of every cottage. One resident had two. The Harold Haines Sr. cottage had the first indoor toilet after Mrs. Haines discovered a snake in the outhouse. Mr. Haines rigged up a tank on the roof, which created a gravity flush.

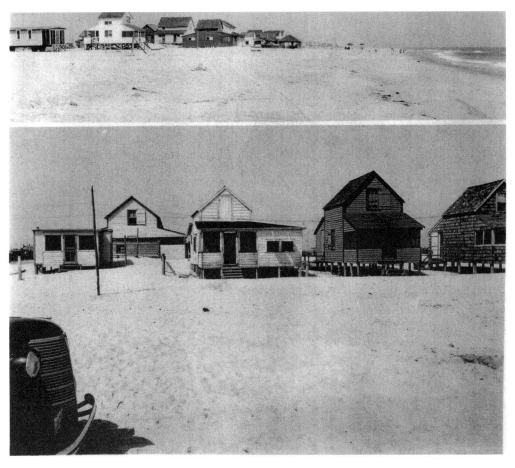

These cottages were just over the Maryland line in what was called Maryland Beach. Note the pavilion on the beach. *Photos courtesy of the Delaware State Archives.*

Of course, you had to hand pump the water up there first. Bathing was simple. It was the ocean or a galvanized tub. If you wanted a shower, you hand pumped a tub of water and set it outside to warm in the sun. Then you poured it over your head.

Because there were no roads either to Ocean City to the south or Bethany to the north, excursions were not undertaken lightly. A trip to Ocean City meant driving west and then south to Berlin, Maryland, and following old Route 346, which is near the present Route 50, east into Ocean City. A trip to Bethany involved driving through the back roads to Ocean View and then heading east on Route 26 to Bethany. The only road in Fenwick was a dirt path that went as far as the old Coast Guard station (converted from the lifesaving station). It was just wide enough for the mailman's car. Groceries were brought in on a weekly basis, and because there were no side streets or Bunting Avenue, every purchase had to be hand carried from the dirt road, which is now Coastal Highway, across the dunes.

Since there were no lifeguards, the Fenwick children learned to spot forming currents, holes and other dangerous situations in the ocean. There was no swimming alone, and it was agreed that inner tubes were not permitted. On one occasion, a visiting Sunday school class went for a morning swim. When they were all trapped in the same rip current, the men of Fenwick raced through the backyards, cutting everyone's clothesline. They spliced together a long lifeline that eventually brought everyone back to safety.

With no television sets or movies, the early residents found themselves on their own for entertainment. Many books were read and games played. Categories was a favorite word game and jigsaw puzzles were popular. Monopoly went on endlessly, especially on rainy days. When the ocean was too rough for bathing, everyone piled into the car to go to Yellow Banks, a sandy beach across from the south of what is now Harpoon Hanna's Restaurant. Many a Fenwick child learned to swim in the calm bay waters of Big Assawoman. Movies were shown in Selbyville and Bishopville, and if you attended on "dish night," you were given a free dish.

The road north to Bethany was built in the early 1940s, and the road south to Ocean City was opened soon after. Fenwick was no longer a secret, and the beginning of development was in sight.

Squatters No More

By the late 1930s, there was a line of cottages from the Maryland border to the area now identified as Georgetown Street. For many years, Virgil Wiley's sturdy shingled house, at what would later become Essex Street, had the distinction of being the farthest north, but no more. In 1936, Bond Smith built north of Wiley, at what is now Farmington Street, and briefly represented the end of the line. Not for long, however, as three ministers—Dr. Carl Rasmussen, Reverend Howard Warren and Dr. Roy Helfenstein—moved their cottages from the "Maryland Beach" north of Bond Smith's place.

The State of Delaware had taken note of the fact that there were beginning to be significant numbers of "squatters" on state land. As has been noted earlier, most of the early houses were quite basic and built with the understanding that they might have to be moved eventually. Sam Bennett, a farmer on the west side of the ditch, did a good business moving these early, lightweight houses with his two mules. By March 1940, the state issued an ultimatum to the squatters at Fenwick, Delaware: either vacate the property by October 1940 or the state would remove the houses.

A Fenwick Beach Association of property owners met on March 31, 1940, to discuss the problem and to come up with a strategy. Roland F. Scott, of C.L. McCabe's Clothing for the Discriminate (later Scott's); Virgil Wiley, supervising principal of the Bridgeville School District; and J. Bond Smith, a Washington attorney, met many times to develop a proposal to interest the state in selling the land to those persons who were occupying it. A Georgetown attorney and later a judge, Caleb Wright provided local legal advice. The directors of the Fenwick Island Beach Association were Vance McCabe, John Furman, Mrs. Ada McCabe, E.V. Condron, J.C. Evans, Samuel LeKites, T.S. Johnson, Roland F. Scott, J. West Mitchell, Brice E. McCabe, Adolphus H. Watson, Mrs. John Peden, L.R. Outten, Horace Lynch, Ralph H. Link, Cashar Evans, Virgil Wiley, Fred Magee, Cecil H. Fisher and J. Bond Smith. Paul Pepper's father, Fred Pepper, who was in the Delaware General Assembly, had tried unsuccessfully to interest the state legislature in authorizing the sale.

On September 25, 1941, after months of meetings, the State Highway Department notified the property owners that it had subdivided the tract of land at Fenwick and was offering lots for sale to those occupying them. The prices would be $200 for oceanfront,

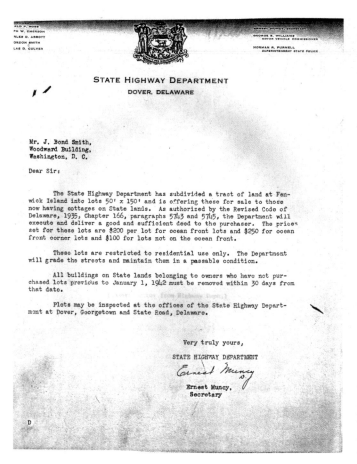

ALD F. ROSS
PH W. EMERSON
RLES D. ABBOTT
ORDON SMITH
LAS D. CULVER

ERNEST MUNCY, SECRETARY
GEORGE R. WILLIAMS
MOTOR VEHICLE COMMISSIONER
NORMAN R. PURNELL
SUPERINTENDENT STATE POLICE

STATE HIGHWAY DEPARTMENT
DOVER, DELAWARE

Mr. J. Bond Smith,
Woodward Building,
Washington, D. C.

Dear Sir:

The State Highway Department has subdivided a tract of land at Fenwick Island into lots 50' x 150' and is offering these for sale to those now having cottages on State lands. As authorized by the Revised Code of Delaware, 1935, Chapter 166, paragraphs 5743 and 5745, the Department will execute and deliver a good and sufficient deed to the purchaser. The prices set for these lots are $200 per lot for ocean front lots and $250 for ocean front corner lots and $100 for lots not on the ocean front.

These lots are restricted to residential use only. The Department will grade the streets and maintain them in a passable condition.

All buildings on State lands belonging to owners who have not purchased lots previous to January 1, 1942 must be removed within 30 days from that date.

Plots may be inspected at the offices of the State Highway Department at Dover, Georgetown and State Road, Delaware.

Very truly yours,

STATE HIGHWAY DEPARTMENT

Ernest Muncy,
Secretary

This is the letter sent to Fenwick "squatters" from the State Highway Department, offering lots at Fenwick to those who were already occupying them. Note that the oceanfront lots sold for $200.

$250 for front corner lots and $100 for lots not on the oceanfront. "All buildings on state land belonging to owners who have not purchased lots previous to January 1, 1942, must be removed within thirty days of that date," the notification stated.

Not everyone thought the price was a bargain. Virgil Wiley commented in a letter to Bond Smith, "We are paying two hundred dollars for lots not worth two hundred dollars; two hundred and fifty dollars for corner lots where there are no streets." There was no rush to purchase the lots, as rustic Fenwick may not have been the summer retreat many folks had in mind, with no electricity, no streets, no garbage or police protection, no lifeguards and no sewers.

One complicating factor was that each structure had to be moved onto a lot as subdivided. Since it had been the custom to place houses anywhere at all before the creation of lots, there were many houses that had to be moved. And because Pearl Harbor followed the state's decision to sell, many of the houses were not moved before the January 1, 1942 deadline.

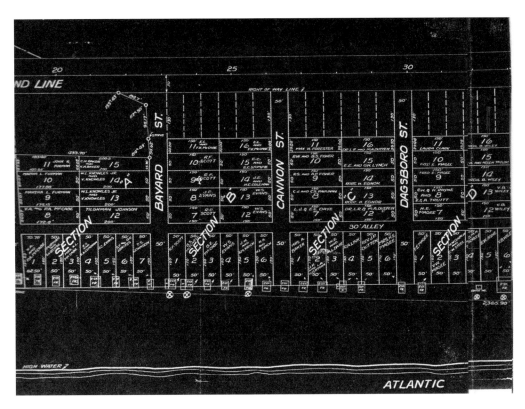

This and next page: Plot of Fenwick dated August 5, 1940 (revised 1942). It shows that many of the cottages were not exactly on the lots as subdivided by the State Highway Department. Those were required to be moved to conform with the plot. *Courtesy of the Office of the Recorder of Deeds, in and for Sussex County at Georgetown, Delaware, in Book E.J.A. 335.*

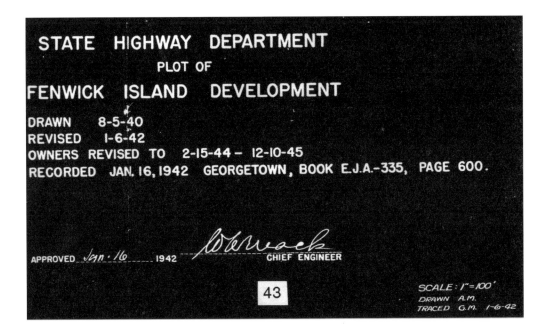

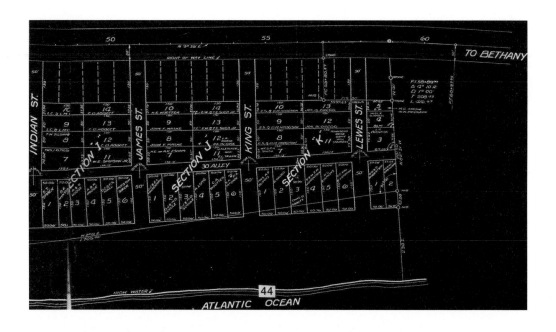

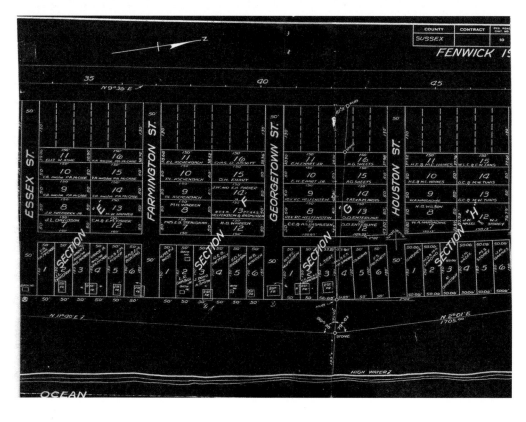

World War II[45]

The advent of World War II brought many changes to the lives of the early residents. Most important was the difficulty in reaching the beach. With the imposition of gas rationing, it was imperative that gasoline be used sparingly during the winter so that gas rationing stamps would be available for summer. Most families came and stayed for the summer. Boating was seldom undertaken, and bikes were used for minor excursions.

There were many other war-induced lifestyle changes. Although in the beginning of the war not much attention was paid to coastal security, later the numerous submarine attacks on coastal shipping mandated that security be tightened. Army units stationed at Bethany made hourly foot patrols. The Coast Guard, ensconced in the lighthouse buildings, made patrols on horseback. No lights were to be visible from the beach, so the choices were to install dark green "blackout" curtains, put plywood over the windows or sit in the dark. On hot nights it was suffocating to sit inside with the windows down and the oil lamps burning. Usually, the windows were closed because the breeze would cause the curtains to flutter, exposing light. "Douse dat light!" became a familiar order from the soldiers. So, most people opted for sitting in the dark. The lighthouse was even turned off, but not until April 1942.

German U-boats and Delmarva

It took a while for the connection to be made between offshore sinkings and shore-created light. Michael Gannon reports that

> *Americans were continuing to act as though there was no war; the beach and towns were still a blaze of light; lighthouses and buoys still operated as in peacetime, though some were dimmed. Shipping still moved singly from point to point rather than follow zig-zag courses on sheltered sea lanes; merchantmen used their wireless without discipline, particularly on the six-hundred meter distress wavelength; many proceeded with lanterns lit; and the U.S. Navy and Army anti-submarine air forces, through inexperience and poor training, still failed to follow up initial attacks, with the result that in shoal water where they stood a good chance of succeeding, they abandoned their attacks too early and withdrew.[46]*

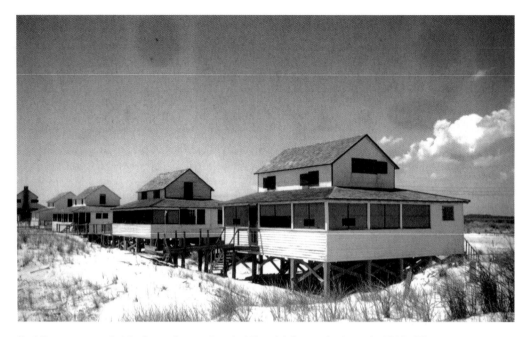

Carl Rasmussen took this photo of several typical Fenwick houses in the early 1940s. They were oceanfront houses between Farmington and Georgetown Streets. *Left to right*: J. Bond Smith cottage, Reverend H.B. Warren cottage, Roy C. Helfenstein cottage, Carl C. Rasmussen cottage and the Teat cottage. The first three houses were destroyed in the 1962 storm. The Rasmussen house was moved to what is now the corner of Bunting and Georgetown Streets, and a new Rasmussen cottage was built in the late 1940s on the same lot.

The U-boats were having what the Germans termed a "happy time." They had proven that they could, on one load of fuel, cross the Atlantic both ways with enough fuel left to operate for several weeks. In February 1942, forty-eight vessels were sunk and seven damaged in the Atlantic coastal region. Most of these were tankers.

Admiral Karl Donitz felt that by striking in the Atlantic coastal area, the all-important lifeline carrying supplies to England would be disrupted. Gannon argues that

> the U-Boat assault on merchant shipping in the U.S. home waters constituted a greater strategic setback for the Allied war effort than did the defeat of Pearl Harbor.[47]

George C. Marshall agreed, stating in June 1942, "The losses by submarines of our Atlantic seaboard, and in the Caribbean now threaten our entire war effort."[48]

Lights went out in Fenwick on April 18, 1942. Fenwick residents, accustomed to walking to the backyard privy by the beams of the lighthouse, now had to find their way in the dark.

> There were twelve U-Boats on patrol between Atlantic City and Norfolk between 1939 and 1943. The destroyer U.S.S. Jacob Jones, under the command of Lt. Commander H.Q. Black, was the first warship sunk in American waters. It was

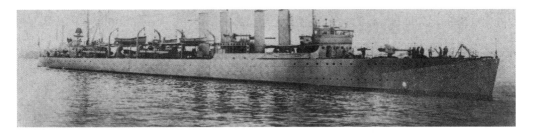

The United States destroyer *Jacob Jones* was torpedoed twice off the coast of Ocean City, Maryland, on the morning of February 28, 1942, by the German submarine fleet. It is estimated that between 125 and 150 men lost their lives when the *Jones* sank. *Photo courtesy of Mariner's Museum, Newport News, VA and the Ocean City Life-Saving Station Museum.*

torpedoed off the Delaware coast February 29, 1942. Between 125 and 150 men died, with only the eleven men in the engine room surviving. Ironically, it had just sailed from New York on a submarine hunt. The Jones still lies off the coast, a tomb for most of her crew. Following the sinking of the Jones, a coastal blackout was imposed.[49]

The concrete tower just north of Fenwick is a reminder of the impact of World War II on the area. The tower, contrary to public perception, was not erected to prevent a coastal invasion. Instead, the tower contained triangulation systems that were intended to provide protection for the entrance to Delaware Bay. The tower and eleven similar structures up and down the Delaware coast provided information for large gun target settings on surfacing German submarines. These guns were fired at a range that made impossible a visual sighting of the landing of their shells. The towers served as their eyes. The tower at Cape Henlopen has been renovated and is open to the public.[50]

Reports persist that Germans landed from U-boats not far from Fenwick. Two items interested the Germans: maps and newspapers. Early in the war, ship sailings and arrivals were still being reported in the press. Captain Donald Stewart reports that two men landed in North Ocean City. After hitchhiking into Ocean City, they purchased maps and newspapers. They told the driver of the vehicle that gave them a ride that they had been fishing and that their car was stuck in the sand. Although they were also stopped by a Coast Guard patrol, they were able to convince them that they were surf fisherman. They signaled the submarine, which landed where they had been dropped off hours before. They submerged off Chincoteague, then shelled the luckless freighter *Olinda*. The captain gave the crew time to abandon ship before sinking the *Olinda* and even threw them some provisions. Imagine their surprise at receiving a can of "Maryland Chief" tomatoes purchased ashore the preceding day.[51] Another report maintains that when a German submarine was sunk off Indian River Inlet, local bread wrappers and groceries were found amid the wreckage.[52]

Following is a list of ships sunk by German submarines during World War II off Delmarva's Eastern Shore:[53]

TYPE	NAME	DATE
Tanker	*Francis E. Powell*	January 27, 1942
Tanker	*W.L. Steed*	February 2, 1942
Freighter	*David H. Atwater*	February 2, 1942
Freighter	*San Gil*	February 3, 1942
Tanker	*Indian Arrow*	February 4, 1942
Tanker	*China Arrow*	February 5, 1942
Freighter	*Olinda*	February 18, 1942
Destroyer	USS *Jacob Jones*	February 28, 1942
Barge	*Alleghanny* [sic]	March 31, 1942
Barge	*Barnegat*	March 31, 1942
Tanker	*Tiger*	April 1, 1942

A Town is Created

By the late 1940s and early 1950s, increasing development brought new problems. Although there were still very few year-round residents, an ever-increasing summer population was finding the need for services. Visitors from cities were accustomed to police and fire protection, and they wanted lifeguards. With the opening of the Chesapeake Bay Bridge in 1952, it was apparent that there would be no decrease in Fenwick's popularity. Concerns about creeping commercialism were beginning to be expressed. The residents of tiny Fenwick feared most that the town could become "another Ocean City," and they sought protection through incorporation.

It was not so easy to determine exactly where Fenwick really was, to be sure. When the State of Delaware transferred ownership to private individuals, the plot was described as the "Plot of Fenwick Island, Delaware." However, south of Atlanta (later to be renamed Atlantic) Street, there was another section that had been locally referred to as the "Delaware Beach" section. This land had been in private ownership. Because the original owners were not squatters, there were some commercial enterprises in Delaware Beach.

When the property owners south of what is now the incorporated town were given the opportunity to be included in the town, they declined. The certainty of additional taxes and more restrictive zoning were possible deterrents. Thus, it was decided that the town of Fenwick would include the area from Atlantic Street northward, as plotted in *Plot Book 2*. Many of the same citizens who were instrumental in persuading the state to sell the land to cottage owners were involved in convincing the legislature that Fenwick should be incorporated. The act to incorporate the town passed in July 1953. The first council members, who were to serve until an election could be held, were: Vollie M. Lynch, George J. Schultz, Vance A. McCabe, Charles D. Thompson, John R. Furman, Cecil Fisher, William W. Clark, Helen West, Adah McCabe and Virgil Wiley. Virgil Wiley was designated the first president of the council, Adah McCabe was secretary and Helen West was treasurer. J. Bond Smith was legal adviser.

Noteworthy in the charter is the language, carefully calculated to preserve Fenwick's residential quality. In Section 26, the town is specifically precluded from establishing a boardwalk: "The town shall have no power to construct a boardwalk along the beach either on private or public property." The charter also was specific in providing the town

the right to regulate the height of buildings. The important provision was spelled out in greater detail in the zoning ordinance that followed.[54]

The first police chief was Donald Evans of Selbyville, and the first lifeguard was Sonny Long of Dagsboro, who had the dubious distinction of having to patrol the whole beach unassisted.

When Fenwick's zoning ordinance was written in the early 1950s, it was said to be one of the only two such laws in the state of Delaware. Fortunately, J. Bond Smith provided expertise in zoning matters, gained while he was general counsel for the Maryland National Capital Park and Planning Commission. The ordinance was very specific about defining residential and commercial space and a mandated thirty-foot height limit. Years later, this provision was instrumental in helping Fenwick resist the high-rise condominium fever that raged in Ocean City in the 1970s. Developers lost interest in such limited structures. Definitions were also included as to what types of businesses could be permitted. The restrictive ordinance is said to have allowed Fenwick to maintain its unique status as a single-family, low-rise community.

In addition to the ordinances, two other man-made activities affected the landscape. First, dredging on the west side of what is now the Coastal Highway produced many new lots. Lagoons were cut in the marsh to provide access for boaters. The residential area of Fenwick eventually doubled, then tripled. The Town of Fenwick annexed the bay side as far as the alley by the Fenwick Crab House. Second, the town participated

This postcard shows the proliferation of trailers adjacent to the lighthouse in the 1970s.

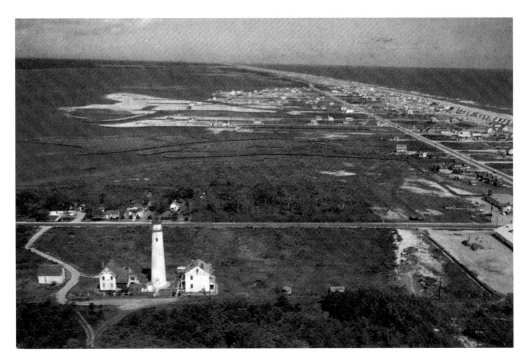

This postcard shows Shulz Road in the process of development. It was a dredged project.

in a state project to renourish the beach following Hurricane Gloria in 1988. Gloria had leveled the dunes in 1985 and made the town very vulnerable to additional storms. The beach nourishment project pumped sand from offshore dredges onto the beach, creating a new width of 110 feet. The process was partially repeated in 1992, following the devastating storm of January 4, 1992.

Sussex County's approval of a sewer system for Fenwick in the late 1970s also provided a stimulus to new construction and improvement of existing structures. Previously, homeowners were dependent on septic systems, which generated numerous problems, especially on the bay side where the water table was closer to the surface. Some residents complained, only partially joking, that they could not do the laundry unless the tide was out.

Another change was observed in Fenwick's skyline, as larger residences were being constructed. The small summer cottage was becoming a thing of the past. Many old cottages were razed and replaced with new permanent homes costing $200,000 and up.

Many homeowners who had previously enjoyed summer visits, decided to winterize their homes and retire to Fenwick. As the year-round population approached two hundred, an active women's club, a Lions Club, a year-round church and a rejuvenated yacht club were created to help fill the needs of the community. A new community building was constructed and financed jointly by the Delaware Bicentennial Fund and the hard work of Fenwick townspeople who paid off the town's share by holding an annual Fenwick Fair.

And so, progress came to Fenwick, changing forever the sleepy summer resort into a year-round town.[55]

Part IV
Shipwrecks, Storms and Witches

March

The stormy March has come at last,
with wind, and cloud, and changing skies;
I hear the rushing of the blast,
that through the snowy valley flies.

—William Cullen Bryant[56]

Shipwrecks

Fenwick's location just west of the Fenwick Shoals made it a graveyard for ships. For many years, a lightship was stationed offshore to mark the shoals.

According to local diver Gene Hastings, there are four major wrecks near Fenwick.[57] The *Nina*, a navy tugboat, sank around 1910. Divers have found the wreck, just off north Fenwick, to be a good source of antique bottles. The *Manhattan* wreck is just east of the Maryland-Delaware line. The freighter *Manhattan* collided with the schooner *Agnes Manning* northeast of the Fenwick lightship in 1889. Its was discovered only recently, as divers had been looking for it farther out to sea instead of inside the shoals. Incredibly, two of the other nearby wrecks were also the result of a collision. On January 26, 1915, the three-hundred-foot schooner *Elizabeth Palmer* rammed the *Washingtonian*, which was a new luxury liner. The passengers on the *Palmer* were saved, but eleven others on the *Washingtonian* drowned. At the time of its launching, the *Elizabeth Palmer* was the largest five-masted schooner in the world. The *Washingtonian* apparently thought it had time to cross the *Palmer*'s bow, but it made a gross miscalculation of speed.[58]

Other wrecks near Fenwick that are of historical interest may not be as interesting to divers as those described by Gene Hastings, but they are worth noting. Maritime records indicate that the *Jan Melchers* sank on May 5, 1888. On October 29, 1889, the steamship *Cleopatra* collided with the *Crystal Wave*, a sidewheel steamer. On October 27, 1891, the *Red Wing* was caught in a northwest gale and broke up in the surf north of Bethany. Several of the seamen in this wreck are buried in the cemetery at Ocean View Presbyterian Church. In 1911, the schooner *O.D. Witherill* was sunk. The year 1915 saw the nine-hundred-ton schooner *Dora* go down off Fenwick. In 1919, a two-thousand-ton schooner, *Neosho*, wrecked, and in 1923, the tug *Underwriter* was towing three barges when stiff winds developed. The barge lines had to be cut and one of the barges sank.[59]

Although the *Faithful Steward* sank closer to the Indian River than to Fenwick, it is of special interest because of the coins that have been uncovered over the years. The *Faithful Steward* sank in a storm in September 1785, only one hundred yards off the beach. There was speculation as to whether the captain and the first mate had possibly overindulged in alcohol at a shipboard anniversary party given by two passengers. Because of heavy seas, only 68 of the 249 passengers and crew aboard were saved, despite the proximity to land. The cargo was said to include Irish and Scottish immigrants, plus gold, silver

and copper coins. Hundreds of Irish and English coins from the reign of George III of England have been picked up downstream near what is now called Coin Beach.[60]

The Money Bank was another site about two miles south of Fenwick where many coins were found. Some old-timers have speculated that widow Zippy Lewis, who lived nearby, supported herself by collecting them. D.J. Long reported that "a man named Truitt" discovered the Money Bank. News traveled quickly, and soon the Money Bank was the scene of all-night bonfires, as optimistic treasure-seekers waited out the tides. D.J. Long thought the silver coins may have come from the *DeBraak*, which wrecked near Cape Henlopen in 1798.[61] This theory seems questionable in view of what we know about coastal current patterns. In any event, others suspected that the coins came from a ship wrecked off the Maryland coast in 1820.

Much later, a surprising sight in 1941 was the large Norwegian freighter *Olaf Bergh* sitting just off Ninety-fourth Street in Ocean City. Although most observers first assumed that it was a victim of a German U-boat, the fact is that is was hard aground. Two theories were advanced: one was that the captain had mistaken the Fenwick Lighthouse for the one at Cape May and had made a sharp starboard turn; the other was that the cargo had shifted in a storm, making the ship's guidance unstable. The ship was eventually refloated and sent on to Philadelphia, its intended destination. During

The *Elizabeth Palmer* at the time of its launching. In 1901, it was the largest five-masted schooner in the world. In 1915, the *Palmer*, while passing off the coast of Ocean City, Maryland, collided with the steamship *Washingtonian*, causing both vessels to sink. Divers are now recovering fragments of the wrecks for display in the Ocean City Life-Saving Station Museum. *Photo courtesy of the Mariner's Museum, Newport News, VA, and the Ocean City Life-Saving Station Museum.*

the period of repairs, the Norwegian sailors made their way into the Ocean City bars, where they surprised everyone by drinking only warm beer.

Delaware's Underwater Treasures

Sunken Ships Recall Nautical Legends

These are some of the most interesting ships submerged off the northern Delmarva coast:

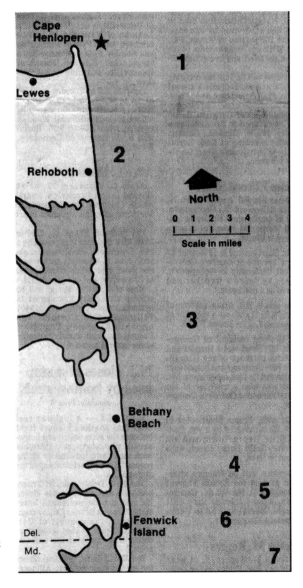

This map charts the location of vessels sunk off the Delmarva coast. *Information provided by Eugene B. Hastings.*

DeBraak: a British warship, it sank in 1798. It is rumored to have been carrying gold, silver and other precious stones that would be worth millions today. Finders-keepers doesn't necessarily apply, however. Because the *DeBraak* is within the three miles of ocean water in Delaware's jurisdiction, the state has first crack at anything officials deem to be of significant historical value.

"The China Wreck": so-called by divers because it contains thousands of dollars worth of nineteenth-century English china. Its origin is uncertain, although it is presumed to be British. Found in 1970, it appears to have been wrecked for a century or more.

Sarah Lawrence: this five-masted American schooner was tied up at Lewes in 1909, when a storm tore it loose and overturned it.

Southern Sword: there is nothing elegant about this U.S.-owned vessel that went down in 1946. But it has the distinction of being one of the few two-hundred-foot coal barges available to undersea explorers.

Nina: a navy tugboat that sank around 1910, it was discovered in the mid-1970s and has been the source of many antique bottles prized by collectors.

Elizabeth Palmer: this five-masted American schooner is infamous because it accidentally rammed the luxury liner *Washingtonian* in 1915, sinking both. Today, it is noted as a home to oversized lobsters that regularly turn up on treasure divers' dinner tables.

Manhattan: one of the most recent discoveries, the *Manhattan*, found two years ago, is a freighter that was the victim of a collision in 1889.

Washingtonian: it was only a year old at the time of its accident with the *Elizabeth Palmer*.

Hurricanes and Storms

Hurricanes and other storms have had significant influence on Fenwick as they opened and closed inlets and moved the coastline. High winds probably pounded Delaware's coast since the glacier retreated twelve thousand to fifteen thousand years ago. Native Americans did not record storm activity, so the first written account of storms in the New World was by Columbus, who wrote of violent weather in the West Indies. The first English visitors to the Outer Banks of North Carolina described a "likely tropical storm" in June 1586, according to weather historian David Ludlam.

One of Fenwick Island's first European visitors, Henry Norwood, landed there because of a storm. Norwood writes in his report, "Voyage to Virginia, 1649," that he was put ashore from a storm-battered ship on January 3 to explore an inlet at Fenwick Island. For whatever reason, the ship's captain did not return to pick him up. As previously reported, he was assisted by the local tribes, who guided him back to Virginia.

However, once the colonists began sending news back to England, weather records improved. A report entitled "Strange News from Virginia" described damaging storms in Virginia in 1667. In October 1692, a "violent storm" hit Delmarva, cutting many of the inlets along the coast.[62]

Possibly, the early settlers of the southern Delaware coast did not make a distinction among the different types of storms. We know today that a hurricane usually comes ashore between June and October, with the heaviest damage on Delmarva frequently occurring between August and September. We think that the term "hurricane" originated from *Hunraken*, which means "storm god" in the language of the Native Americans of Central America. To qualify as a hurricane, the winds must blow over seventy-five miles per hour, originate near the equator and have an average life of twelve days. A nor'easter is most likely to occur between September and April, after developing somewhere between Florida and Delaware. Because they usually last several days, nor'easters can be as destructive as hurricanes and have been responsible for the most severe coastal damage in recent years.

Coastal storm damage is determined by the wind (direction, velocity, duration and fetch), storm track (speed with which it moves and its position relative to the coast) and storm surge. The storm surge is the result of a reduction in atmospheric pressure. In hurricanes, the sea level rises thirteen inches for every drop of one inch of mercury

below the norm of 29.92. Another factor in coastal storm damage is wave action. Scientists tell us that one cubic foot of water weighs 1,620 pounds when moving at thirty miles per hour.[63]

Coastal Delmarva has been damaged by many hurricanes and nor'easters since written records became available. For our purposes, we will discuss only the most destructive, the most bizarre or the most relevant to the Fenwick area.

Druley Tide—January 15, 1831

When there were few residents in the coastal area, storms were frequently named for those who drowned in them. In the Fenwick area, the storm on January 15, 1831, was named for Captain James Druley. Druley was a sea captain who lived near Bayville, just west of Fenwick, and was drowned in the Indian River Inlet during the storm. The same storm was designated "Norman's Flood" in the Rehoboth area for the Thomas Norman family, whose home was washed away.[64]

Dorothy Pepper recalls that Mame Laws reported that her grandfather was an eyewitness to the storm, which washed inland with such intensity that "sheep and cattle were left hanging in the trees" when the tide went down. Tide levels were thirteen to sixteen feet above marsh level and certainly higher on the oceanfront.[65]

Weather historian David Ludlam confirms that the Druley Tide was not a local phenomenon.

> *The storm center of this gigantic disturbance stayed offshore after starting its northward run from the Carolina area. Winds everywhere were from the northeast. Along the southern shore and Delaware Bay, tides were raised from two to four feet above anything experienced before. There were many shipwrecks along Long Island and southern New England.*

A Cape May paper reported three feet of snow and that "cattle and sheep drowned by hundreds." Ludlam termed it "the greatest snowstorm of the nineteenth century along the Atlantic seaboard."

Ice Storm of 1895

In the winter of 1895, the ice was so thick on the ocean that Jim Bishop Sr. drove a team of horses and a snow sled onto the sea without mishap. The ice piled up as high as the roof of a cottage and did not melt until April. Several oceanfront cottages at Fenwick were destroyed by the ice buildup. Ice was reported to be fourteen inches thick at the Old Mill Pond in Selbyville.

The Blizzard of 1888

The blizzard of 1888 is of interest because of the startling loss of ships. At Lewes, twenty-three ships were wrecked, as they were literally blown onto the beach. Trains were stranded in snowdrifts.[66]

The Great Storm of 1889—September 10–12

A northeast wind blew for several days, until it reached near-hurricane strength. Reports from Rehoboth stated that Surf Avenue was washed away and the surf was breaking over the Bright Hotel. Twelve schooners and one bark went ashore. The people of Lewes and the employees of the U.S. Life-Saving Service were busy aiding a total of twenty-two vessels and rescuing thirty-nine passengers. No lives were lost.[67]

The Storm of 1933

The storm of 1933 was a hurricane that flooded the coast during the week of August 20. Winds of seventy-five to a hundred miles per hour whipped up twenty-foot waves, leveling the dunes. Almost eleven inches of rain fell.[68]

The significance of the 1933 storm was that it tore through Ocean City and cut an inlet where none had been before. The town fathers had already agreed that an inlet would be desirable, and they had begun planning how to proceed when, unexpectedly, they had an inlet. The ocean, which had flooded Ocean City to the bay, began to be pushed back eastward by northwest winds. The retreating waters cut through at a low point in south Ocean City. The advantages of the new inlet to Ocean City were not immediately apparent to everyone, for many buildings had been swept to sea. The most important loss was the collapse of the railroad bridge. The railroad had been very important to the development of Ocean City, providing convenient access by train from Berlin. No wonder the residents were perturbed!

The Storm of 1962—March 5–8

The storm of 1962 was, by far, the most destructive storm ever to hit Delmarva. It tops the Delaware Geological Survey's list of the top ten storms to hit Delaware since 1912.[69] On Monday, March 5, 1962, local weather forecasters warned of a nor'easter. To local residents, a nor'easter is a three-day blow of no special concern, but Nancy Pigman, the local weather person on Salisbury's WBOC, warned that two low pressure systems were building up. The barometer read .29, a sign of bad weather to come.[70]

Early Tuesday, March 6, the two lows merged into one storm, and at the absolute worst time of the lunar cycle. Tides were already predicted to be higher than usual.

However, the U.S. Weather Bureau at Baltimore was sure that the wind would switch to the northwest. It didn't, however, and thus began what has been called the "storm of the century."

The strong northeast winds began to pile up waves of twenty to thirty feet. Unlike most storms in the Northeast, which generally subside after two high tides, this storm persisted through March 8 with two high tides on Tuesday, the sixth; two on Wednesday, the seventh; and two on Thursday, the eighth. Sixty-mile-per-hour winds, heavy snow and rain covered the shore. The Wednesday morning tide turned out to be particularly destructive.

By Wednesday night, the Ocean City boardwalk was breaking up and crashing into oceanfront hotels and residences. The Ocean City Fire Company was struggling through two and three feet of water on the streets to make rescues. If you were stranded and could not get out alone, you hung a white sheet out the window. The fire company rescued many residents and transported them to the Route 50 bridge, where school buses took them inland. Many went inland to the Buckingham School, while others went to stay with friends. Several dozen hardy residents, however, remained.

The tide cut through the beach at Seventy-first Street, causing the road to collapse as a new, temporary inlet was created. Unfortunately, a Trailways bus driver on his way to work in Ocean City was trapped when the road collapsed and his car fell into the new inlet. He and a fisherman, who drowned off Assateague, were Maryland's only deaths. The newly created inlet was also the cause of the burning of two houses in the area. These structures were located north of Seventy-first Street, and the fire company could not reach them. No one could come in from the north due to flooding at Fenwick. The National Guard was called in to patrol.

Residents reported having witnessed a wave totally overwash and momentarily obscure a house built on a hill at Sixty-ninth Street.

Finally, when it was all over, there was much speculation in Ocean City about the cause of the storm. One was heard to blame it on John Glenn's trip into space; another thought nuclear testing was at fault; but a third felt that she had the answer when she said, "Ocean City had the storm because the Methodists tore down their church to build a bigger one."[71]

In Delaware, things were just as bad. At the Indian River Inlet, even members of the Coast Guard had to evacuate. With no way out, they walked seven miles north to Dewey. In Rehoboth, the boardwalk was ripped up, and the oceanfront wall of the Atlantic Sands Hotel collapsed. Twenty-eight of twenty-nine oceanfront homes in Bethany were destroyed, and water up to five feet deep was flooding the town. The Holiday House on the boardwalk was swept away. Television star Dick Clark's oceanfront house near Fenwick was totally destroyed.

In Fenwick, the damage was equally severe. All of Fenwick was flooded except for an area near the lighthouse. Sand was washed into the side streets and onto Route 1. The dunes were destroyed by the pounding surf, giving the thirty- to forty-foot ocean waves an unobstructed opportunity to undermine the oceanfront houses, causing them to topple forward and to break up. The ocean flowed westward into the bay and lagoons,

The Fenwick oceanfront after the 1962 storm. Notice the houses, which were moved by the waves.

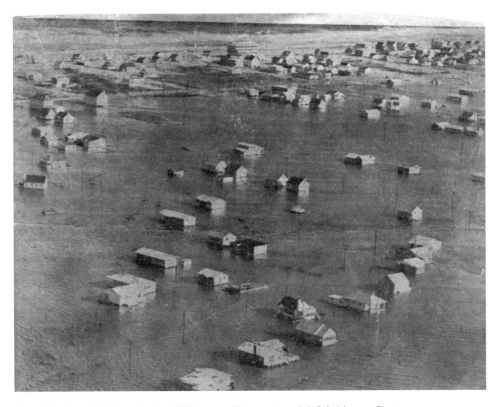

Fenwick at low tide following the 1962 storm. *Photo courtesy of the* Washington Post.

A freezer and chair that were blown away in the storm.

This is one of hundreds of small boats driven inland two or three miles.

This car, a Nash, went off the road near Bethany during the storm and was quickly filled with sand and water as the storm rampaged through the area. *Photo courtesy of Mr. and Mrs. Paul Pepper.*

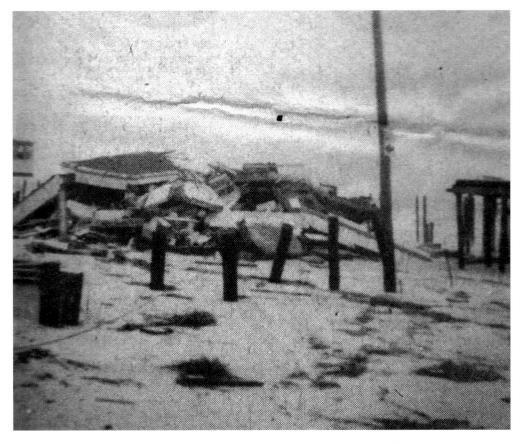

The Holiday House Restaurant on the Bethany Boardwalk was another victim of the storm's rampage. The restaurant, which was leveled in the storm, has now been rebuilt and is a popular eating place. *Photo courtesy of Mr. and Mrs. H. Harbison Hickman.*

and the bay side was also inundated with water washing back from the west. There were three feet of sand in most of the streets. When it was over, seven people had died in Delaware. The damages were estimated to be $212,000,000 (1962 dollars).[72]

As in Ocean City, the National Guard was called in to protect the damaged property along the Delaware beaches. However, looters made their way in by boats and removed articles known to have survived the storm. In one house, a picture was neatly cut from a frame and stolen. In another, only the cutlery drawer disappeared.

Soon, the state began pushing the sand back onto the beach. Fires burned daily as houses that were too badly damaged to be repaired were destroyed. By summer, much of the damage had been cleaned up. For the first time, an ocean-made saltwater pool extended the length of the beach, much to the delight of the small children. It remained there all summer.

The bridge over the Indian River Inlet suffered some foundation damage and was temporarily closed. (See appendix for additional information.)

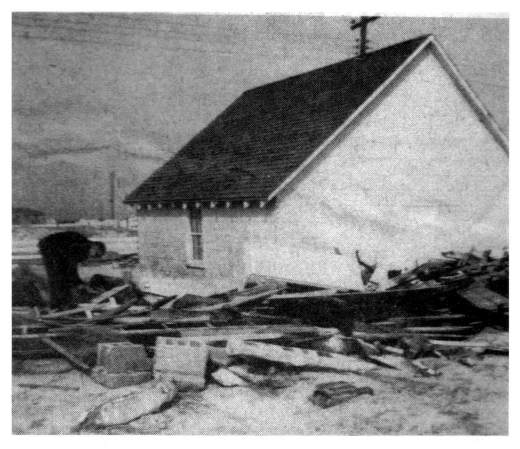

The storm scattered debris for miles. Property owners then gathered for the time-consuming chore of sifting through the rubble to find their own possessions.

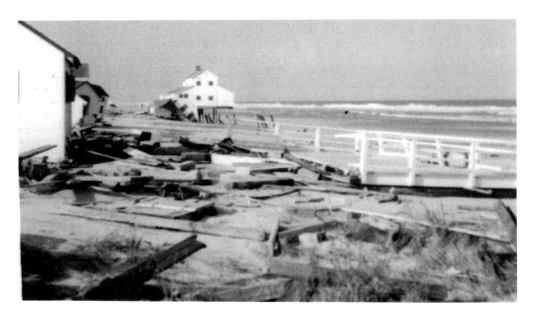

Wreckage from the Bond Smith house.

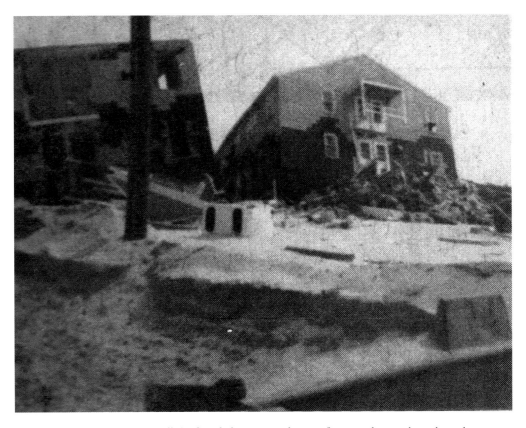

The storm knocked this house off the foundation, as was the case for many homes throughout the area. *Photo courtesy of Mr. and Mrs. Clifton L. Johnson.*

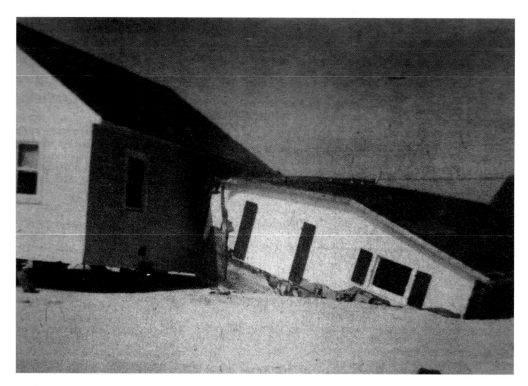

The ocean rearranged many neighborhoods.

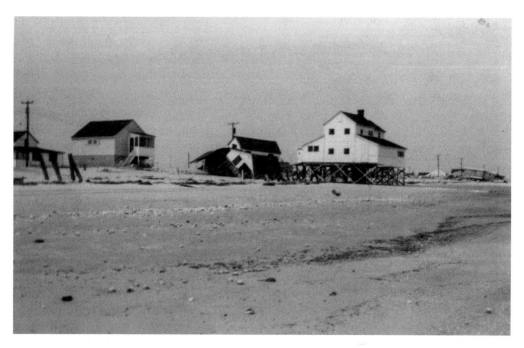

The wreckage of the Helfenstein cottage. As the waves destroyed the first floor, the second floor fell on the sand.

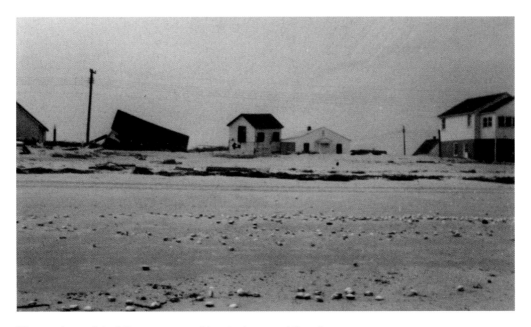

The wreckage of the Warren cottage with only the second floor in tact.

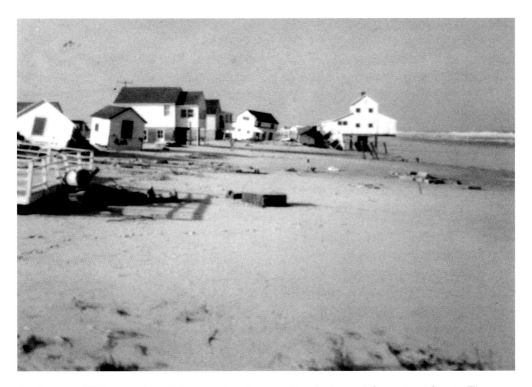

Another post-1962 storm view of the oceanfront between Farmington and Georgetown Streets. The Rasmussen house is the only one left standing from Georgetown Street to Essex Street. The Rasmussen house was almost hanging by its chimney and might have also been destroyed if there had been a sixth high tide.

Storms in the 1980s

In the years before beach nourishment, winter and spring storms were especially threatening. The high tide came up regularly, almost to the houses. In South Bethany, before beach nourishment, Ocean Drive was damaged so often that the town gave up paving it.

Two storms, one in February 1983 and one in early April 1984, brought surprisingly high winds and seas. No houses at Fenwick were lost, but they were threatened. These storms helped to galvanize public opinion and led to the lobbying for aid to the beaches. (See additional accounts of these storms in the appendix.)

Hurricane Gloria—September 27, 1985

If there were any nonbelievers on the beach, Hurricane Gloria in September 1985 helped convince most of them that beach nourishment was imperative. The difference between Gloria and the other major winter storms was that Gloria was well predicted. At least twenty-four hours before Gloria came ashore, it was being accurately plotted by the weather service. Fortunately, the 150-mile-per-hour predicted winds did not materialize. Instead, the fast-moving storm generated a fast-moving storm surge, which quickly overwashed Fenwick, dumping debris on Bunting Avenue and Route 1. The dunes were leveled, but most of the houses were undamaged. None was lost.

The Surprise Storm of January 1992

The Delaware Geological Survey has rated the nor'easter on January 4, 1992, as the second worst storm since 1912, based on tidal levels at Breakwater Harbor. The maximum winds, although only blowing fifty miles per hour, once again coincided with the high tide.

The old saying that Delaware has "three counties at low tide and two at high tide" was almost correct. The ocean, whipped by the wind into enormous waves, poured over Fenwick, flattening the dunes, spilling into the lagoons and then creating new sandbars on Route 1. The whole town was underwater during the period of high tide.

Fenwick residents were caught completely by surprise, as weather predictions had called for tides only three feet above normal. The high tide, or what appeared to some observers to be a storm surge, came just after daybreak, when some residents were still sleeping. Imagine their surprise to see twenty- to thirty-foot waves breaking on the beach.

Fenwick was isolated, with Route 1 closed in both directions due to flooding and debris. Route 54, Fenwick's connection to the west, was flooded, as usual. Days passed before traffic returned to normal. In the meantime, the Fenwick police kept sightseers at bay and looters on their toes. There was little theft, compared to the 1962 nor'easter.

Fenwick residents were caught unaware as a surprise storm barreled through the dunes and washed down the side streets, January 1992.

The post-storm assessment revealed that there was significant damage to Fenwick's streets. Most oceanfront owners discovered that they had structural damage, or flooding, and many had three feet of sand under their homes and in their driveways, but no homes were lost. Those who had witnessed the storm realized what a close call they had had and were thankful.

Delaware Geological Survey's list of the top ten storms in Delaware since 1912 (based on tide levels at Breakwater Harbor):[73]

1) March 4–6, 1962—nor'easter
2) January 4, 1992—nor'easter
3) September 27, 1985—Gloria, hurricane
4) October 25, 1985—nor'easter
5) October 22, 1961—hurricane
6) March 29, 1984—nor'easter
7) October 15, 1977—hurricane
8) October 23, 1953—nor'easter
9) December 22, 1972—nor'easter
10) January 13, 1964—nor'easter

Matilda

The Storm Witch[74]

Perhaps some of Delmarva's storms can be blamed on Matilda Van Ech, the "Bad Weather Witch." According to Ocean City historian Captain Donald Stewart, Matilda was aboard the ship *Dudderode* in 1673, when it anchored off of Lewes. Matilda, an orphan because her parents and her younger brother had not survived the voyage, came ashore, and Lewes widow Dame Gronedick took her into her home on Lewes Creek, where her son Pieter also lived.

When Captain Thomas Howell's troops came from the west in 1673 to claim Lewes for Lord Baltimore and the Colony of Maryland, they were commanded to burn every house and structure in town. Captain Howell assembled the townspeople to warn them to remove their possessions from their homes before the burning began. The troops torched the Gronedick home and were on their way to the barn when Matilda placed herself in their path and refused to move. Captain Howell prepared to ignite the barn, but suddenly a bolt of lightning stuck the ground between Howell and Matilda. Captain Howell reportedly cried, "My God, we have a witch here!" The barn remained untouched—the only shelter remaining for the Dutch family of Lewes.

Pieter and Matilda married. Pieter became a fisherman; Matilda tended her geese. In 1688, Pieter was killed by pirates who had come ashore near Lewes. A group of townspeople pursued the pirates and forced them back to their ship. A grieving Matilda went to the shore to view the pirate ship, still anchored offshore. A violent storm moved in and sank the pirate ship. The pirates drowned.

Matilda's personality changed after Pieter's death. Neighbors observed her bathing nude in the creek while others said that she brewed potions. She seemingly lost interest in her farm and her geese. The Reverend Davis of the Presbyterian church proclaimed Matilda a witch. He ordered her to "be gone from this place." Matilda laughed at him and threw powder in his face, causing him to be speechless for two hours. Mysteriously, lightning struck Davis's house that night.

Harassed by the militia, Matilda moved to Assateague Island, where she lived until her death in 1733. Militiamen reported that when they surrounded her house in Lewes she turned into a goose, so they burned her house. She never forgot Delaware, however. On her deathbed, she reportedly cursed the Delaware coast, saying:

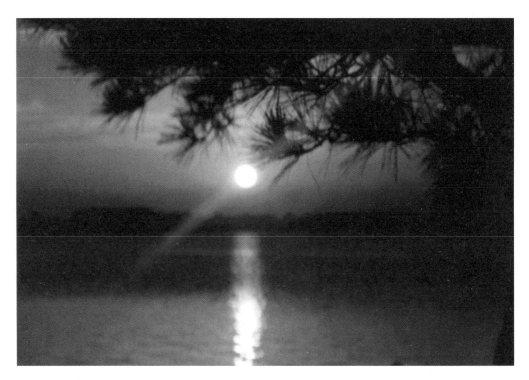

Sunset over the bay.

Fenwick's back bay is an attractive stopover for snow geese. Usually, huge flocks raft up in the late afternoon, moving to the ocean in the morning—out of range of the local hunters.

Violent winds will corrupt yer coast from both northeast and southeast. In odd years, I wilt bring the vast torrents of sea, wind and fire…I will wreck ships that sail betwixt my domain, rendering some of their cargo for the support of my loyal friends. Each century henceforth will ye know me well. I vow to maintain my constant watch and ye will know me by the size of my flock—four pairs and the widow Matilda.

Not long after Matilda's death, a violent storm struck the Delaware-Maryland coast. One hundred years later, in 1833, a storm pounded the coast and made five new inlets on Assateague. Another hundred years passed, and the storm of 1933 struck the coast, cutting the Ocean City inlet. (If 2033 brings a major storm, you will know whom to blame.)

So Long

When geese fly high
from Canada
and the black ducks
flock and skim
the water, we know
the time is near
for us to pull
the boats and sack
the sails, to drain
the pipes, and turn
the chairs, empty
refrigerator and pantry
latch all the windows,
lock the doors and hie.
Summer is gone
and fall is going.
So long, Fenwick,
You can count on us
like ducks and geese
to the very last
we'll know you're HERE,
HERE…HERE…

—Roy Basler

Gone Tomorrow

We have seen that Fenwick, as we know it, is the result of many forces. Geological history has recorded the changing shoreline and the effects of storms. Human intervention has altered the geology by dredging and filling the bayside, creating artificial lagoons and replenishing the ocean-side beach. Residents' need for storm protection has produced continued beach nourishment and increased bulkheading to protect properties. One possible effect of this activity will be to hold the beach and bayside in its present location, instead of permitting the island to migrate westward, as it would do without interference. Geologists warn that the ultimate result of trying to hold the beach in place may be the "drowning" of the island. And yet, with millions of dollars invested in public and private property, there does not seem to be any choice.

Incorporated Fenwick, as we know it, has been affected not only by geology, but also by a determination on the part of the property owners to maintain a relatively quiet, low-rise, single-family beach community. This determination has been evidenced by the charter and zoning ordinances that clearly restrict development. As a result, Fenwick has been termed "an oasis" for some who have fled other more commercial resorts. At the present, a commercial tract runs only along both sides of the Coastal Highway, providing shopping, restaurants and banks.

Long-range future prognostications are not too optimistic. As Dr. John Kraft reminds us, "The shoreline and coastal zones have varied back and forth, throughout time, over a several-hundred-mile width."[75] It would be difficult to imagine that this process would magically stop, as much as we might wish it.

Scientists are not encouraging, pointing to the fact that the rate of sea level rise appears to be gradually increasing due to the greenhouse effect. Increased warming may cause the beginning of some melting of the polar ice cap, increasing the rate of rise. Further, Dr. Kraft also detects a downward settling of 130 feet in the continental shelf in the past ten thousand years.[76] Some coastal engineers predict that as a result of these forces, Baltimore will one day be oceanfront. Others are not so sure. A few scientists claim that a trend is developing for the beginning of a new ice age. Obviously, only time will tell which view is correct.

Meanwhile, visitors may wish to recall again the language of the 1898 prospectus of the Fenwick Island Land Company—

It seems as if nature, knowing how tired human beings would become in the great hurrying of the city had specifically provided this place as a restful haven, where the persons of glamour and refinement could dwell almost within sight of the glimmering lights of the great cities, and yet far enough to be free from the artificial existence of town and its fever-haunted atmosphere

—and enjoy it while they may.

Epilogue II (2008)
Revitalization

We were fortunate to receive a significant beach re-nourishment project in 2005–6, which doubled the size of the beach. In addition to providing a more attractive space for tourists, the additional sand affords added protection in the event of a major storm. Our new, wider beach enabled the Town of Fenwick to provide benches on the dune for those unwilling or unable to travel through the sand to see the ocean.

The Town of Fenwick also converted an unused portion of its property into an eye-catching park, which is a playground, a meeting place and an attractive garden. A highlight of the park is the "Walk of Fame," consisting of commemorative bricks purchased by residents to honor friends and relatives. It creates an interesting walk with the bricks recalling the many who are no longer with us—and some who are. The park is used for town functions, such as a Memorial Day observance, a Christmas tree lighting and occasional concerts. The women's club hosts a very competitive shuffleboard tournament every summer, as well.

Another project that has vastly improved the appearance of the town is the beautification of the median strip. With the assistance from Del Dot, the concrete has been removed, and the medians are planted with daffodils and azaleas. Recreational activities have moved up a notch with the introduction of the "Fenwick Freeze," our version of a traditional New Year's Day swim. In its third year, the Freeze continues to attract quick bathers and appreciative spectators alike. Every year, over one hundred swimmers take a quick plunge, cheered on by friends and family. Surprisingly, the January weather has so far been warm. A huge bonfire built the first year was watched from a distance, as the air temperature was already seventy degrees.

The continued transition of Fenwick from a resort to a very small town was aided by the revitalization of the Fenwick Island Yacht Club and the establishment of the new Fenwick Island Fishing Club. The yacht club has revived the July Fourth Boat Parade, which travels throughout the town, attracting spectators from all over Sussex County. The fishing club serves the local fishermen by sponsoring tournaments and other services. A municipal water system was installed, and a substation of the Bethany Fire Department was established.

However, although these additions have improved the quality of life for residents, life has not been all fun and games. The biggest enemies to the stability of life in Fenwick

Epilogue II (2008)

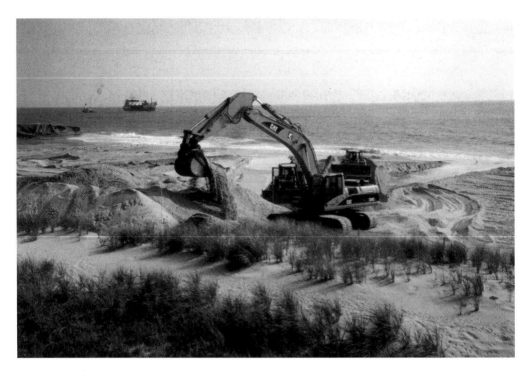

Machinery on the beach.

Beach nourishment with tourists.

Scenes from the newly nourished beach.

Fenwick's new park combines a garden with a playground.

Neil Hanrahan, former director of Public Works, places another commemorative brick in Fenwick's "Walk of Fame."

A rainy Memorial Day in the park finds Jeanne McWilliams and Betty Buehele huddled under an umbrella.

Local steel band, Plenty Problems, directed by John Syphard, performs at the town park.

Left: The concrete median strip was dug up and replaced with bulbs and shrubbery.

Below: The dash is on for the Fenwick Freeze, now a traditional New Year's Day swim, with over a hundred participants.

The reenergized yacht club hosts a boat parade on July 4. This year, the theme was "Holidays." This sailor is celebrating Thanksgiving.

are Mother Nature and humankind. When Mother Nature sends us a hurricane or a devastating nor'easter, there's not much we can do but board up, pack up and leave. The threat humans bring to Fenwick is more devious, but slower moving. Sea level rise is certainly a concern, but it's not too clear yet just how and when it will affect us. In the past ten years, Fenwick residential properties have continued to be very sought after. There have been challenges to the town's ordinances that restrict height of buildings to thirty feet. Some residents feel that this ordinance is the key to maintaining a low-rise, residential, town.

Another problem has been the proliferation of very large new houses, dubbed "McMansions." The construction creep toward larger houses came about gradually, until the town realized that it had a request for a building permit for a house containing seven bedrooms and seven bathrooms! Fearing that an explosion of these large homes would forever change the character of the town, the town council adopted an ordinance limiting construction to five bedrooms and four baths. Also, and perhaps even more importantly, a limit of twelve was established for the number of persons permitted in a rental. It was hoped that these ordinances would prevent the proliferation of "small hotels," which had begun to appear.

Were these past ten or twelve years our "Golden Years"? Will we one day look back and marvel at how much was accomplished? It is likely that the town will continue to be an attractive target for development, some of which may not be in keeping with the

low-rise density many have come to treasure. At present, there is a hardy, but aging band of residents who attend town meetings and do what they can to beat the drum for small-town preservation. Help will be needed from a new generation of activists. Through the years, Fenwick has represented substantially different attractions for a variety of groups. The Native Americans came to Fenwick every summer to enjoy the cool breezes and do a little fishing; the pirates came to stash treasure and hide in our back bays; the lighthouse keeper arrived to tend the lighthouse, warning ships away from the dreaded Fenwick Shoals; the salt maker came to derive salt from the ocean; and the Christians came to establish a religious camp meeting. But all came to enjoy what Fenwick had to offer and not to destroy it. Once again, let us consider the prospectus of the Fenwick Island Land Company in 1899:

> *It seems as if nature, knowing how tired human beings would become in the great hurryings of the city, had specially provided this place as a restful haven.*

We certainly need to try to see that our "restful haven" stays that way.

Appendix

Selbyville Resident Recalls '62 Storm

Delmarva News, *March 3, 1982*

It seemed a good idea to Paul Pepper that Tuesday in 1962 to ride down to the beach to check his cottages near the Maryland-Delaware line. He had been hearing reports about storm damage along the New Jersey coast and he wanted to check the local area.

Paul invited his wife Dorothy and in-laws Doris and Harvey Williams to ride down with him in his truck but at the last minute Mrs. Pepper remembered she had a meeting to attend so she decided not to go along.

Paul's familiarity with the tendency of Rt. 54 to flood made him decide to go to Fenwick via Bethany. The ride to the beach was uneventful until he passed South Bethany where he discovered the ocean pouring across Route 1 about seven or eight inches deep.

After checking to be sure the road bed was still in tact, they proceeded to an area just north of Fenwick where they were flagged down by two state troopers. At this point, the road looked "just like the inlet," Paul recalls. The police told Paul that they had reports that 12 to 15 people were marooned at the Lighthouse Diner and asked if he would pick them up in his truck.

Paul agreed to try. But this time when Harvey walked out to check the road he found himself knee-deep in water. Roots from the beach grass torn from the dunes caught his legs and whirled him around. Harvey yelled at Paul, "We'd better get out of here!" Paul agreed.

They headed back to South Bethany and found that the State Police car had water pouring through it, that a Nash car had gone off the road and that a State Highway truck had also become stuck in the sand. Voletus Bunting and William Long were driving the highway department truck that had been sent to pick up State Police Troopers George Brewington and William Willen when the truck veered off the road.

Meanwhile, James Wolf and Donald Melson were on patrol for Delmarva Power and Light when their truck had gotten stuck near Fenwick. The two men radioed in to their office and were told to abandon the truck and head for safety. They could see the lights on Pepper's truck shining through the darkness and ran from Fenwick as fast as they could

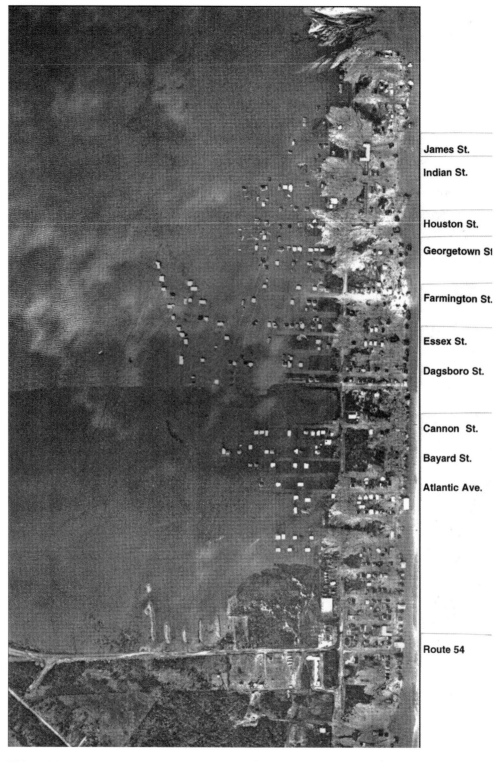

James St.

Indian St.

Houston St.

Georgetown St

Farmington St.

Essex St.

Dagsboro St.

Cannon St.

Bayard St.

Atlantic Ave.

Route 54

This aerial photo shows clearly the amount of flooding in the 1962 storm. The whole town appears to underwater in this DNREC photo.

through the storm to reach Paul's truck. "My God, I never thought I would make it. We grasped each other at times to keep from being blown away," Wolf told Paul. When Wolf finally reached the truck he only had one shoe sole left.

The driving rain and the high winds had left them all soaking wet. There was no heat and no dry clothing available, so the men occasionally ran around inside the back of the truck to keep from freezing.

By now, Paul's truck could not go anywhere. The road to the south was completely flooded and Pepper saw sides of houses and furniture wash by. The group could only stay huddled in the truck and wait to be rescued.

Meanwhile, Dorothy Pepper was not too worried about her husband's absence. No one in Selbyville realized how serious the situation was at the beach until later in the evening. Since Paul was Selbyville's Fire Chief and Dorothy had heard that the fire company had been called out to fight fires at Fenwick, she assumed he was with the fire company.

The fire company had begun to wonder where Paul was but had not yet called Dorothy. When Doris and Harvey's children called looking for their parents, Dorothy brought the children to her home to wait for them to return. But as time wore on, she became more and more concerned and began calling various people to see if anyone knew where Paul and the Williamses were.

At one point, close to midnight, the Salisbury radio station carried a report that Paul was missing and asked that anyone knowing his whereabouts call the station. But, because it was so late at night, few local people heard the message. Dorothy continued to wait until Paul reappeared the next day.

When the tide went down, the National Guard came in with a tank and rescued Mrs. Arthur Wondreck and Mrs. Lethmay Coffin from the Fenwick area near where the power company truck had gotten stuck. Mrs. Coffin's house, located behind what is now Oliver Cropper's trailer park, had broken in half during the storm. She was stranded there in an old feedbag dress and raincoat until she was rescued.

Mrs. Coffin and Mrs. Wandreck, whose home had also been destroyed in the storm, had taken refuge behind a tall sand dune to ride out the storm's fury.

The tank then picked up most of Paul's passengers but the Williamses, Voletus Bunting and Paul stayed behind with the truck. Later the National Guard came in with a wrecker to tow the stranded vehicles but only succeeded in falling into the ditch itself while towing Paul's truck causing the front of his truck to be stuck, too.

Finally Paul and his group rode back to Bethany with the National Guard and then Paul found a ride back to Selbyville. On the ride back to Bethany, the severity of the damage finally began to strike Paul as he passed an area littered with debris which only hours before had been the site of rows of new homes.

On his way home, Paul had talked with one of the National Guardsmen who told him that he thought most of the Peppers' property at the beach had been destroyed.

Paul and Dorothy were determined to get to Fenwick to see their cottages and finally got in with the National Guard. In fact, Dorothy was one of the first women to be allowed into the area. As they rode out to their cottages they found that every oceanfront cottage from Delaware to the Carousel had washed away. But their apartments and all of their

cottages except one were safe. Their original cottage, which had been oceanfront for 29 years, had been moved back from the ocean less than one week before the storm and so it had been saved.

The Peppers also found that Jim Swann's pile driver, which had been driving piles in front of their cottages before the storm, was still in place although one of the large buckets had been lost.

There was an eight to ten feet drop from the cottages to the beach after the storm because of the erosion. But even the telephone booth at the cottages had survived the storm with only one foot to spare before it would have tumbled from the yard.

Mrs. Pepper says she believes the area just south of the Delaware line was hit hardest by the storm because there were no dunes to help absorb the waves' attack. The higher dunes at Fenwick apparently helped protect more of the homes there although the damage was still quite bad.

She recalls talking with Mrs. Coffin after she had been rescued at Fenwick. "Whatever were you thinking when your house broke in half?" I asked her. And she said simply, "I just said my prayers and left it all up to the Lord."

Freezing Temperatures Cause Ocean to Freeze Along Shore

Delmarva News, *January 27, 1982*

Visitors to the shore on Friday were treated to a very unusual sight—ice extending all the way to the outer sandbar where waves usually break at low tide.

The frigid temperatures caused the wave to freeze as they washed up on the shore, creating lovely scalloped patterns of ice. As each wave froze, the ice flow widened until there was a solid sheet of ice, at least on the surface.

The breaking waves carried in the large chunks of ice, possibly from Delaware Bay, so that they sounded like ice being crushed in a blender. After the wave was broken, the crest then disappeared under the layers of ice, resembling a snake under a blanket.

There was no noise of waves washing into the shore, as this sound was absorbed by the ice. The only sound was from the crashing, ice-filled breakers. The sharp crack of the breaking wave sounded something like a car door slamming, causing one dog to bark all afternoon, apparently thinking company was coming.

The conditions thus created were hazardous to sight-seers, as the frozen layers were not completely solid. Strollers on the ice could be walking over deep water, not really realizing that the ice was not firm, but slushy underneath.

By Sunday, warmer temperatures and heavy rains caused the ice shelf to retreat, leaving only a line of jagged chunks of ice. A field of robins was observed off Rt. 64 near Ward in Sussex County. It was not clear whether the birds had not left the area yet, or whether they are back early from their southern vacation. But, we can only hope that they know something that we do not—that spring is on its way.

Property Owner Remembers Giant Waves Along Del. Coast

Delmarva News, *March 3, 1982*

In its early stages, the storm of '62 had been vastly under-reported in the Washington press. But radio reports of damage elsewhere had attracted our attention. I phoned friends in Salisbury who could tell me only that they had heard Ocean City had been hit hard and that a new inlet had been cut around 70th Street.

Concern about the fate of our oceanfront home prompted my sister, Barbara Griffith, and me to decide to drive to Fenwick, as this was apparently the only way we would get any information.

Our father, J. Bond Smith, had died recently, and we felt responsible for attending to any problems which the storm could have caused.

Off we went on Thursday (the last day of the really high tides), accompanied by our husbands. We were very wise, we thought at the time, to take a hammer and nails "in case anything had come loose." But we were not too concerned because the house, built in 1936, had survived several hurricanes without problems.

The tension-filled car trip was halted on Rt. 54 at the entrance to Keenwick West. At this point the road was completely flooded by several feet of water and impassable. The only access was by Army tank.

The National Guardsmen took one look at me and seeing that I was more than just a little pregnant, said "No way." So, the men went off, carrying the hammer and nails and cameras. My sister and I were left behind. We searched for a vantage point from which we could see the beach, and found one, a tine burial plot in a field north of Rt. 54. The small cemetery was elevated just enough to give us a view of the beach.

And what a sight it was. Although we were approximately three miles inland, we could see huge breakers coming in to the shore and completely washing over the beach in to the bay near the area of Fenwick Towers (built since the storm). The huge breaking waves are a sight I will never forget.

With binoculars we began searching the line of cottages, looking for ours. We knew that ours was slightly higher than its neighbors, and the roof line should have been visible. It wasn't.

The men later returned to confirm our worst fears. The house was indeed gone. Fenwick was a wreck. Houses and wreckage were strewn everywhere. The dunes were completely gone. In our area, every oceanfront home between Rasmussen's, at Georgetown St., and Andrew's, at Essex, had been destroyed or knocked down.

It was a sad trip back to Silver Spring, where we had to inform our step-mother, Ayesha Smith, of the disaster.

The hammer and nails rode back to Silver Spring unused.

Storms in the 1980s

Delmarva News, *February 23, 1983*

As usual, the dog was unerring in her instincts. Friday morning she retreated to the bedroom to get away from the wind and put her head under the bed. She never moved all day.

Those of us who did, witnessed an awesome storm. In the pre-dawn hours Friday morning the wind started to blow a steady 40 mph from the northeast. The morning waves were to the dune line by 7 am with breakers cresting off shore.

Sleet and freezing rain fell sideways. Friday afternoon winds were in excess of 60 mph and creating nasty conditions. At 3 pm it seemed advisable to inform the weather station in Wilmington the winds were gusting to 72 mph. Previously they were blowing at 55–60 mph.

They said, "no kidding," but promised they would start to back around to the northwest around 7 pm.

We wondered if that would help us when high tide was predicted for 7:30 pm.

By 4 pm huge trains of waves were breaking so far off shore that white water was visible over halfway to the horizon. The house was creaking and shaking to the rhythm of the wind. The house plants were blowing in the breeze with all the windows shut. There were even waves in the toilet bowl. Shingles were standing straight up on many roofs.

We could not help but wonder what was happening to the newly installed Seascape at Bethany. We wondered if it was buried with the incoming sand or uprooted and washing to shore?

The water level on the coast side of the dunes rose higher and higher. As the base of the dunes were attached, the cave-ins occurred. The water was raging southward.

We tried in vain to recall just what the Anderson door salesman said about how much wind could be tolerated. The afternoon's big worry was whether the doors would shatter. Reports of plate glass windows blowing in at the Carousel did little to allay that fear.

Just to be safe, a get away bag was assembled containing car keys, safe deposit box keys, last year's W-2s, the Fenwick Island Women's Club tickets to the March flower show and overnight things.

As high tide approached the biggest waves ever observed by this ocean watcher were crashing to shore.

"Should we evacuate," was the question raised by authorities. It seemed unlikely that we were in immediate danger of washing away, but it seemed equally certain that much of the protective dune would be lost. Anyway, by now icy conditions could have caused as many problems as the sea. And where would we evacuate to? In-land was blanketed with snow. Evacuation was ruled out.

So the high tide approached, gobbling the dunes. The weatherman was accurate in his prediction of the wind change and sure enough the wind did back around to the northwest before high tide. This did help. More important was the fact that the winds died down to 20–30 mph which by then seemed gentle as a summer breeze. The dunes held.

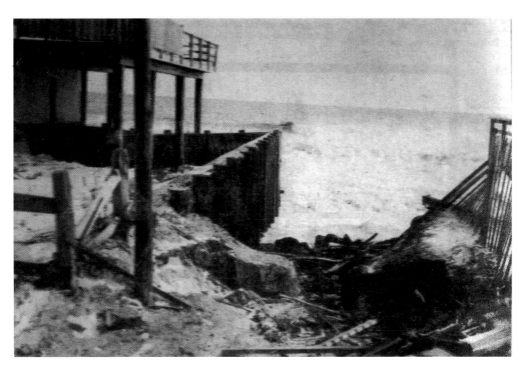

Storms in the 1980s took their toll on South Bethany.

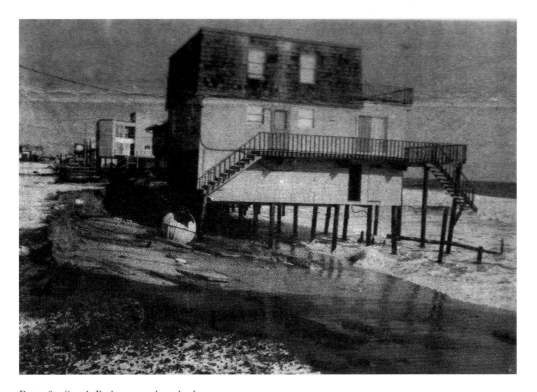

Part of a South Bethany road washed away.

It takes a long time for the ocean to calm down after it has whipped itself into such a frenzy, and by Saturday morning there were still sizeable waves. But the storm had passed, leaving bright sun to shine on the blowing spray.

The dog came out from under the bed, and all was present and accounted for. Thanks for another reprieve.

Water, High Winds Batter Coast—Storm of April 1984

Delmarva News, *April 4, 1984*

High winds, heavy seas and relentless rain resulted from an unusually large and slow-moving low pressure system which hung over Delmarva Wednesday and Thursday. The storm, which moved into the area from the south, seemed to have greater impact in the northern coastal area than in lower Sussex; and was said by some to be the worst since 1962

At Fenwick, winds were clocked at 65–70 mph at the inlet and over 80 mph in Rehoboth. The barometric readings of 28.5 were unusually low, and the low pressure combined with the high winds to generate trains of enormous waves.

The waves eroded beaches all along the Delaware coast. The new condominium at the Maryland-Delaware line found its manmade dune removed and was absolutely at the water's edge.

In Fenwick, the dunes were breached in some low lying sections, with water swirling around some residences. Bunting Ave., between Houston and Indian Streets, was closed temporarily, as water came over the dune, and later leveled it. No oceanfront homes were reported damaged, but the dunes which were just re-building from the February, 1983 storm took a beating and were severely battered. Once again, there are cliffs at the street ends as though someone had taken a giant knife and sliced them in half.

At South Bethany, the tides Thursday morning caused extensive damage to Ocean Drive. Water surrounded the oceanfront houses and washed down many of the side streets. Sewer lines were again exposed in many cases. The fill placed by many property owners to provide driveways and protect Ocean Drive was mostly removed. Debris was washed everywhere. An unusual sight were the pilings recently driven for yet another oceanfront house. Surrounded by water, they resembled a boat dock more than a house.

At Bethany, waves crashed over the street ends and washed down the side streets. An unusual sight was a mound of foam in front of the Baltimore Trust Bank. Some oceanfront streets resembled lakes for at time. The boardwalk was not damaged, but some of the steps to the beach were removed by the surf. At Sea Colony, some of the parking lots were flooded, mostly from the rain.

Route One was flooded north of Bethany, but completely impassable north of the inlet, where ocean washovers removed the dunes, leaving the road under water. Route 1 was not reopened until Friday afternoon. The inlet bridge remained undamaged.

The northeast winds which had pushed the surf up all day Wednesday and early Thursday backed around to the northwest Thursday, and then the trouble began for the bayside residents. Water which had been pushed into the bay at the inlets was forced by the wind back into the streets and low-lying areas.

In Fenwick, bayside houses were surrounded by water, and some residents were unable to get out. However, most just stayed home and watched. No one was evacuated at Fenwick, but Edith Barton reported she had waves on her lawn.

Route 54 was flooded and closed. When the water finally receded, great quantities of debris could be seen along the road.

The fire departments were everywhere. In Fenwick, the Bethany Fire Co. stood by in case evacuation was needed. Residents elsewhere were assisted in leaving flooded streets.

In other areas of Delmarva, flooding created serious problems. Most of Crisfield's streets were reported under water, and many residents were lodged at the high school. The Delaware Bay beaches at Bowers and Woodland Beach flooded, and residents were evacuated at Kitt's Hummock. Reportedly, the Heartbreak Hotel at Bowers Beach closed because of high water.

In Milford, the downtown business district was flooded as the Mispillion River rose. Rehoboth sustained damage to a portion of its boardwalk.

Storm Night Watch

Delmarva News, *April 14, 1984*

Did you ever go to a motel where they have those beds that move? You put a quarter in and get three minutes of gentle motion, supposedly guaranteeing improved circulation and relaxation.

That's what it was like sleeping in my bed in Fenwick on Wednesday night. The bed vibrated with the 65 mph winds, but it was anything but relaxing. Houses elevated on pilings do vibrate in strong winds, but this seemed to me a bit excessive.

As if the Rock-a-Bye-Baby motion wasn't enough, Mother Nature seemed determined to remind us of her superiority once again, and threw in a lightning display. Flashes of brilliant light illuminated the huge waves crashing on shore. The wind and lightning seemed to combine to require attention to the surf, which by now was nibbling at the dunes, and which most of us would just as soon not have to watch.

The lightning was close to force me to get out of bed again to unplug the TV and stereo, and most regretfully, my electric blanket. So now I not only had gale winds and pounding rain, but a light snow and cold clammy sheets to compound my sleeplessness.

I remembered the Feb. '83 storm, similar in many ways, and how the dog had spent the day with her head under the bed.

Dog—move over.

Ditto from Fenwick—Hurricane Gloria

Delmarva News, *September 27, 1985*

Wednesday morning's news reports of an enormous hurricane accompanied by 150 mile per hour winds certainly caught my attention. The weather service thought it was headed in our direction. The strength of the storm placed it as a 4 on the Saffir scale. A No. 4 storm could carry a storm surge of 20 feet, which would send waves breaking on my second-story deck.

Evacuation seemed to be a probability, the loss of my house a possibility.

Plans were quickly made. The fist, most crucial step to take was to fill the car with gas. If the power went off, there would be no way to pump it.

Next, the hurricane "grab" list had to be re-examined. A permanent list of treasures and records was always kept, so that in any quick departure, the important things would not be overlooked. At the top of the list was the flood insurance policy. Next were the house plans, and my tax bill, to identify me as a property owner so that I could come back into Fenwick after the storm if roadblocks were erected.

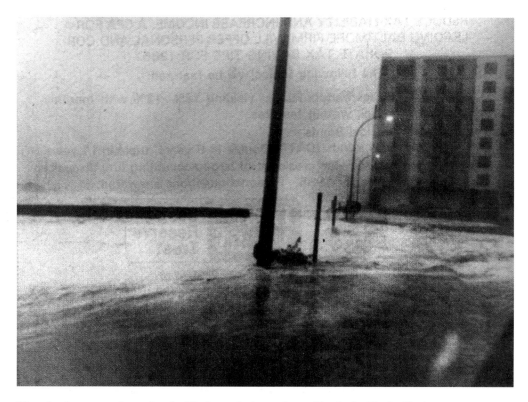

The relentless waves churned up by Gloria reached past the parking lot beside the Henlopen Condominium at the north end of Rehoboth's boardwalk Friday morning. The boardwalk did not withstand the onslaught, and part of it collapsed onto the sand, breaking away from the foundation. *Photo courtesy of Robin Berkowitz.*

Items which could not be replaced, such as the children's baby books and family photographs were assembled. A quick trip to the hardware store provided large waterproof bags for packing everything.

Next the plotting. The weather service broadcasts the hurricane's position periodically. With our hurricane's maps, we could track its progress and see that the storm would probably go ashore at Wilmington, NC.

But wait a minute. The system suddenly began to move in a more northerly direction, meaning that instead of spending its energy ashore, it was aimed at us for sure.

Window taping began, and relocation of TV, lamps, etc. away from the glass doors. Bowls were filled with water and placed in the freezer to provide additional protection, should the power fail. Flashlights were checked. Neighbors' porch furniture was secured, and my son began assembling material to board up the doors.

In Fenwick, there was great activity, as seasonal residents appeared to prepare their houses. Town workers collected bike racks and trash barrels. Fenwick's WeWacs, the experimental wind aerators, were pulled ashore by Louis Steele and Jack Foster and lashed to the dock. Merchants were busily taping and boarding windows. Shopkeepers were even removing letters from their signboards.

By Thursday afternoon, the area was placed on a hurricane warning status. Evacuation plans were set in motion as Ocean City asked all tourists and visitors to leave. Sussex County advised mobile home owners to prepare to move.

Around 5 pm the warnings were more severe. People were taking them seriously, and leaving. Rain began.

As we were loading the final bags into the car, the Fenwick police were advising residents to leave.

The trip through town was unforgettable. The downtown area resembled an abandoned movie set. Everything was covered with plywood.

Not one car was seen on Rt. 54 between Fenwick and Selbyville. Rt. 54, the site of routine flooding, was wet, but passable. The wind was hovering around 20 mph.

As I arrived at my destination in Selbyville, I could feel the intense murkiness in the air, an ominous sign. My hosts, Emily and Bill Hastings, had thoughtfully invited Fenwick residents Art and Mary Skiles and Hank and Amy Goebel from Bethany.

All gathered in front of the TV set, hoping to hear the storm's direction had changed. No such luck. Dr. Neil Frank never had such an attentive audience, as we listened to every word.

We were back at the TV set after a rather short night, at 6:30 am. One of the problems was in obtaining local information. The emergency center at Ocean City had been moved inland, and there wasn't much reporting being done from Ocean City. "Chaos," one reporter said, adding that the water was all over Ocean City and the boardwalk damaged. That did little to raise our flagging hopes.

Another TV news reporter from Rehoboth said that the eye of the storm would pass within two miles of Rehoboth. We're surely sunk, we thought. Channel 47 disappeared from our sets.

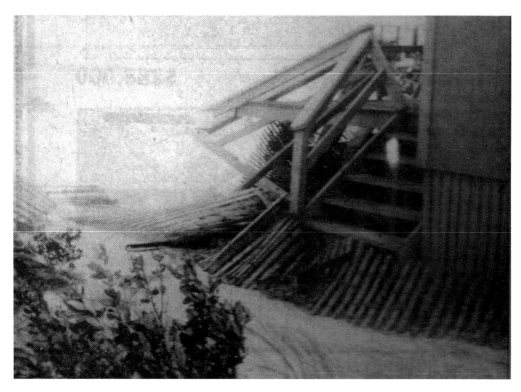

A Fenwick house at the end of King Street loses its decking.

The only light moment in the TV scene was when one of the networks interviewed the Salisbury police chief, in the obviously mistaken belief that they were talking to the Ocean City police department. Although the Salisbury officer kept trying to explain, the network people really weren't listening, and kept asking him about the waves. Those boys needed a map.

The weather service, via the Lewes weather station, announced the storm had passed. Sure enough, the barometer began to rise.

Then the winds began with the greatest intensity of the 24-hour period. Trees fell, branches were everywhere. We moved our cars to an open field. I couldn't help but think how ironic it would be if a tree crashed on my car and all my worldly goods after my cautious evacuation from Fenwick.

The power went off, so we were at the mercy of the local radio station. We learned that six employees and emergency people stayed in Bethany, but there were no reports from Fenwick.

We cautiously entertained thoughts of riding back to the beach. The shelters would soon be emptying, and we decided to make a run for it.

Much to our surprise, we were able to ride all the way, although we did pass through a flooded area on Rt.54.

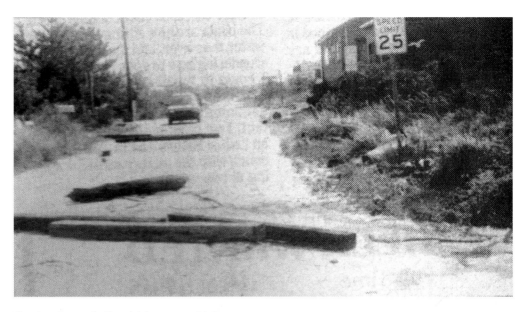

Bunting Avenue in Fenwick is strewn with logs.

As we approached the Fenwick bridge, we shared a common dread of not being able to locate our homes. We really did not know what to expect. We felt that if the winds had indeed been as high as expected, we would not find our houses standing.

We became more encouraged as we saw the Sea Charm and other oceanfront buildings. We had great difficulty driving up Rt. 1 as it was covered with timbers, debris, and sand which the ocean had washed over.

My house was thankfully undamaged. The ocean had passed under it, and most of the dune removed, but nothing had been harmed. The power was even on, and the telephone ringing as I entered. The same cricket I'd left on Thursday was still chirping in the downstairs bedroom, and I had a new tenant outside. A very large ghost crab had moved inland and had dug his hole by my stairs. We all have to cope with the invasion of the sea, so I say welcome, crab.

A Fenwick Woman's First Hand Experience During '92 Storm

Reprinted with permission by The Whale, *January 4, 1992*

"Tides running about three feet above normal." This was the NOAA advisory Friday night.

Three feet above normal is a significant, but hardly devastating, rise in tidal level. Later, the television weatherman said the low pressure system was weakening and possibly moving inland.

When you live on the oceanfront, you learn not to take lightly any storm warning. The forecasts suggested a water level which would probably remove the remnants of our newer, easternmost dunes.

These dunes had built up after the beach nourishment project and had taken a beating in the Halloween storm. However, the beach had begun to rebuild and appeared last week to be reaching its former width. And we still had older, more established dunes for protection, we thought.

Observations periodically through the night confirmed these expectations. Water sloshed over the new dunes but the older dune was still intact. As late as 6 am Saturday it appeared that the dunes would stand. But around 7 am the situation changed.

The winds, which had been blowing due east at 40 mph or more, had whipped the waves into big, fat mountains of sheer energy. The breaking waves made the house shudder. When it became sufficiently light to see, it was obvious that these waves were larger than any in recent memory.

The winds increased and the waves began slamming into the dunes and washing over into the street ends and Bunting Avenue. They suddenly began to level everything in their path, breaking oceanfront walls and windows, scattering shrubbery, burying automobiles and having heat pumps for breakfast.

The water picked up my small Integra, which had been parked under the house, and neatly moved it 50 feet westward. I took this as a personal message that it was definitely time to leave. Imagine my surprise when I discovered that the waves had removed my one and only set of stairs.

When a 20-foot wave is chasing you, you tend not to hesitate to do whatever it takes to get out. Clutching houseplans, flood insurance policy, camera and key to the safe deposit box, I ungracefully slid (mercifully unobserved) 15 feet down a heavy rope which I had found years ago on the beach and had used as nautical décor on my deck. Landing knee deep in surging water, I made my way to hospitable neighbors, Dick and Shirley Polhemus, who live on higher ground near Route One. Other oceanfront friends, Nancy and Jack Padden, sloshed in to wait out the storm.

We all watched the storm turn Fenwick's side streets into wildly flowing rivers, more suited for white water rafting than driving. The whole town east of Route One appeared to be under water, reminiscent of the '62 storm.

By 10 am the water's rage began to subside. We were able to wade out to discover the oceanfront had taken a major hit. Many oceanfront homes sustained damage, although none went down in Fenwick. Bunting Avenue was impassable due to sand and debris, as was Route One.

Water levels on the bayside were reaching the tops of bulkheads but there was not the major flooding sustained where the water cascaded toward the bay.

Fortunately, no lives were lost. Most of the property damage was on the oceanfront at ground level, although some of the older, lower houses suffered greater losses. The Bethany Fire Company was everywhere assisting residents, dealing with propane tanks and power lines. The Fenwick Police were keeping sightseers out.

By Sunday, the DelDOT bulldozers were leaving Route One and Bunting Avenue and those roads were mostly passable. The tide was out, although still much closer to the oceanfront home than anyone would have liked to see. Residents were scurrying to find carpenters and bulldozer operators to remove the substantial amounts of sand in everyone's property.

Observers of the storm agreed that, although much of the re-nourished beach was removed, the dredged sand served its purpose in absorbing some of the wave energy and kept the enormous waves out until the last minute. Had there been no beach nourishment, the waves would likely have been breaking on the oceanfront residences and destroying Bunting Avenue.

A reminder: always keep a list of important items to be removed in the event of a sudden emergency. You never know when you may have to slide down a rope, fireman style!

Last Week's Storm Had Hurricane-like Features

By Barbara Porter, reprinted with permission from The Whale, *January 15, 1992*

Last week's northeaster was unusual from its very beginning. Usually our winter storms form off the Carolina outer banks but this one began off Florida and, like a hurricane, grew in strength as it came. NOAA told us it was on its way but apparently there was no way to predict that it would break into several storms before arriving in Delaware.

One of those storms, the one that hurt us, passed to our west. That put us in the right front quadrant of the low pressure center, where the forward motions of the storm and the direction of its winds were the same, enhancing the storm's strength. With hurricane Gloria we were in the left front quadrant, the gentler one, but last week we didn't have that advantage.

Another hurricane-like feature of last Saturday's northeaster was its storm surge. Vivid descriptions of the surge, around the time of the morning high tide, tell of pavement that was only rain-wet suddenly covered with a foot of salt water. And having over-run the dunes, this water continued to deepen, rapidly. We've been told the surge was three to four feet in height, but that may not be official. I do know, from conversations with Marian Peleski and with Jime Roets, her successor as meteorologist in charge at the National Weather Service office in New Castle airport, that it was not a hurricane we went through last Saturday. True, there were tropical storm "signatures," but hurricanes must by definition have warm cores. This storm had a cool core, although a very tightly wound one, a true eye.

There were other factors, "technical ones" as Marian put it, that made our recent storm a northeaster, not a minimal hurricane. But even as a non-hurricane, this storm has, I think, left us with deepened respect for coastal storms, and probably more willing to evacuate, should we be asked to do so in the future.

There have also been comparisons between the recent storm and the 1962 northeaster. This one was violent but blessedly brief; we had only one storm high tide last week. In '62 there were five storm high tides; this tide-to-tide is what made it so destructive. I won't try to visualize what would have happened last week if we had had such a tidal pile-up.

What we do have now is the sight of the ocean where just a few days ago it was dunes we looked at. Those dunes have, in many areas, either been diminished or flattened. We also had wet sand everywhere, in the first several blocks in the towns, in the developments, and along roads and highways. Bulldozers were pushing this sand back to the dunes and beaches even before the storm had died.

Then there were the interesting smaller things, such as well-planted dunes taking their deeply rooted shrubs and grass with them as they were pushed back by the seas. And, not so small, the breaker line showing that washed away sand remains just off the beach and will probably return before too long.

Notes

Introduction
1. U.S. Geological Survey, *Delaware Place Names*, 42.
2. Hurley and Hurley, *Ocean City*, 24, 25.
3. *Bethany Herald*, 1904; Bethany/Fenwick Chamber of Commerce, *Reflections*, 7.

Part I. The Early Years (200,000,000 BC to AD 1800)
4. Roy Basler, a Fenwick summer resident for many years, was chief of the general reference and bibliography division of the Library of Congress. He was author of *The Muse and the Librarian*, in addition to his volume, *Fenwick Island Poems*.

1. Here Today
5. Kraft, *Delaware Estuary*, 31–39.
6. Groot, *Plant Microfossils*.
7. University of Delaware, "Rare Miocene Fossil Bed Find First on Delmarva," *Update*, April 23, 1992, 1.
8. Kraft, *Delaware Estuary*, 31–39.
9. Maurmeyer and Carey, *Striking a Balance*, 22.
10. Tenny, "Native Names," 23.

2. The First Native Americans
11. Westlager, *Delaware's Buried Past*.
12. Hancock, *History of Sussex County*, 5.
13. Westlager, *Delaware's Buried Past*, 154.
14. Thomas, "Hunters and Fishermen," 2,3.
15. Carter, *History of Sussex County*, 3.
16. Westlager, *Delaware's Buried Past*, 154.
17. Bayliff, *Maryland, Pennsylvania and Delaware*, 12.
18. Westlager, *Delaware's Buried Past*, 154.
19. Carter, *History of Sussex County*, 4.
20. Westlager, *Delaware's Buried Past*, 28.
21. Ibid.
22. Tenny, "Native Names," 22–24.

3. The First White Man

23. Stump, *History of Fenwick Island.*
24. Ibid.
25. Carter, *History of Sussex County*, 43.
26. Fenwick Island Land Co., *Prospectus*, 7.

4. The Great Boundary Dispute

27. Bayliff, *Maryland, Pennsylvania and Delaware*, 12.
28. Carter, *History of Sussex County*, 3.
29. Dick Carter, *The Transpeninsular Line* (N.p., n.d.).

5. Yo Ho Ho

30. D.J. Long, "Fenwick History," *Delmarva News*, July 28, 1938, 10.
31. Fenwick Island Land Co., *Prospectus*, 7.
32. Pepper, *Folklore of Sussex County*, 26.
33. Captain Donald Stewart, "Local Pirate Plunders Delmarva," *Maryland Beachcomber.*
34. Pepper, *Folklore of Sussex County*, 21.

6. Zippy Lewis

35. Fay Brooks, "Zippy Lewis, an Unlikely Heroine," *Daily Times*, February 16, 1992, 5.
36. Long, "Fenwick History."
37. Brooks, "Zippy Lewis," 11.

7. Fenwick Island Lighthouse

38. Pepper and Pepper, "Fenwick Island Lighthouse," 1.
39. White, *The Lighthouse*, 19–21.
40. Pepper and Pepper, "Fenwick Island Lighthouse."

8. Salt-making

41. Tunnell Jr., "The Salt Business."

9. The U.S. Life-Saving Service

42. Hurley and Hurley, *Shipwrecks and Rescues*, 9, 20.

10. Fenwick Island Land Company and the "Ditch"

43. Ibid.
44. Ibid.

14. World War II

45. Mary Pat Smith Kyle, Personal Recollections, 1930–40.
46. Gannon, *Operation Drumbeat*, 309.
47. Ibid.
48. Ibid.

49. Captain Donald Stewart, "U-Boats Off Delmarva," *Maryland Beachcomber*, 1980.
50. Rick Hutzell, "Towers on the Coast: WWII Enigmas," *Maryland Beachcomber*, November 23, 1983; Michael Morgan, "Towers Served Same Purpose as Castles," *The Whale*, January 7, 1991.
51. Stewart, "U-Boats Off Delmarva."
52. Carter, *History of Sussex County*.
53. Hurley and Hurley, *Shipwrecks and Rescues*, 170.

15. A Town is Created
54. Charter of the Town of Fenwick Island, July 1953.
55. Kyle, Personal Recollections.

Part IV. Shipwrecks, Storms and Witches
56. Ludlum, *American Weather Book*.

16. Shipwrecks
57. Eugene Hastings, "Delaware Underwater Treasures," *News-Journal*.
58. Seibold and Adams, *Shipwrecks*.
59. Hurley and Hurley, *Shipwrecks and Rescues*.
60. Ibid.; Seibold and Adams, *Shipwrecks*.
61. Long, "Fenwick History."

17. Hurricanes and Storms
62. Ludlam, "Hurricane Visitations," 48, 49.
63. University of Delaware, *Delaware Coastal Storm Damage Report*, 9,10.
64. Ludlam, "Early American Winters," 11.
65. Pepper, *Folklore of Sussex County*, 12.
66. Ibid.
67. Hurley and Hurley, *Shipwrecks and Rescues*, 142.
68. Ibid.
69. Delaware Geological Survey, "Top Ten Storms," *News-Journal*, February 21, 1993, A-6.
70. Dryden and Dryden, *The Tide of March*, 2.
71. Ibid.
72. "Pictorial Report of Delaware's Great Storm of March 1962," *Delaware State News*, 1966.
73. Ibid.

18. Matilda
74. Carter, *History of Sussex County*.

Epilogue I. Gone Tomorrow
75. Captain Donald Stewart, "The Legend of the Bad Weather Witch," *Maryland Coast Press*, March 1979.
76. Kraft, *Delaware Estuary*, 31–41.

Bibliography

Baker, Denise. *Learning About Delaware Folklore*. Dover: Delaware Arts Council. 1978.

Baltimore Sun. *Storm of the Century*. Baltimore: A.S. Abell Co., 1962.

Basler, Roy. *Fenwick Island Poems*. Sarasota, FL: Bayside Press, 1975.

Bayliff, William H. *The Maryland, Pennsylvania and Delaware Boundaries*. Bulletin no. 4. Annapolis: Maryland Board of Natural Resources, 1959.

Bethany/Fenwick Chamber of Commerce. *Reflections. A Nostalgic Journey Into Our Past*. Bethany Beach, DE: Coastal Printing, 1987.

Breach, Jack, Eugene Ellis, Neal Oechsler and Bob Bennett. *Pictorial Report of Delaware's Great Storm of March*. Dover, DE: Delaware State News, 1962.

Carter, Dick. *The History of Sussex County, Delmarva News*. Millsboro, DE: n.p., 1976.

Delaware State Archives. Purnell Collection.

Dryden, Beverly, and Bill Dryden. *The Tide of March*. Berlin, MD: Eastern Shore Times Press, 1962.

Fenwick Island Land Company. *Prospectus*. Wilmington, DE: Fenwick Island Land and Gunning Club Preserve, 1895.

Gannon, Michael. *Operation Drumbeat*. New York: Harper and Row, 1990.

Groot, Johan J. *Plant Microfossils of the Calvert Formation of Delaware*. Newark: University of Delaware, 1992.

Hancock, Harold B. *The History of Sussex County*. N.p., 1976.

Hill, William T. *The Great Atlantic Coast Storm*. Rehoboth, DE: Atlantic Printing Co, 1962.

Hurley, George M., and Suzanne B. Hurley. *Ocean City, a Pictorial History*. Virginia Beach, VA: Donning Co., 1979.

———. *Shipwrecks and Rescues Along the Barrier Islands of Delaware, Maryland and Virginia*. Donning Co., Virginia Beach, VA, 1984.

Kraft, John C. "Geology." *The Delaware Estuary, Rediscovering a Forgotten Resource*. University of Delaware Sea Grant, 1988.

Ludlam, David. *The American Weather Book*. New York: Houghton Mifflin, 1982.

———. "Early American Winters 1821–1870." *American Meteorological Society*. Boston, MA: n.p., 1968.

————. "Hurricane Visitations to the Delaware Estuary." University of Delaware Sea Grant, 1988.

Maurmeyer, Evelyn M., and Wendy Carey. *Striking a Balance*. Delaware Department of Natuary Resources & Environmental Control, 1985.

Moore, Kevin. Postcards. Indian River Lifesaving Station; World War II Towers.

Pepper, Dorothy. *Folklore of Sussex County*. Sussex Bicentennial Commission, 1976.

Pepper, Dorothy, and Paul Pepper. "An Original Salt Pot." Friends of the Fenwick Island Lighthouse, n.d.

————. "The Fenwick Island Lighthouse." Friends of the Fenwick Island Lighthouse, n.d.

Rasmussen, Carl C. Early Fenwick Photos.

Seibold, David J., and Charles J. Adams. *Shipwrecks, Sea Storms and Legends of the Delaware Coast*. Barnegat Light, NJ: Exeter House Books, 1989.

Stump, E. Charles, IV. *The History of Fenwick Island*. Self-published, 1977.

Tenny, John B. "Native Names." *Delaware Conservationist* (Winter 1988).

Thomas, Ronald. "Hunters and Fishermen of Prehistoric Delaware." *Delaware Conservationist* (Summer 1968).

The Transpeninsular Line. Friends of the Fenwick Island Lighthouse, n.d.

Truitt, Reginald V., PhD. *High Winds, High Tides*. Natural Resource Institute University of Maryland, 1968.

Tunnell, James J., Jr. "The Salt Business in Early Sussex County." *Delaware History* IV, no. 1 (March 1950).

University of Delaware. *Delaware Coastal Storm Damage Report 1923–1974*. Dover: Delaware Coastal Management Program, April 1977.

————. *Delaware's Changing Shoreline*. Dover, DE: Coastal Zone Management, May 1976.

U.S. Geological Survey. *Delaware Place Names*. Washington, D.C.: U.S. Government Printing Office, 1966.

Westlager, C.A. *A Brief Account of the Indians of Delaware*. Newark: University of Delaware, 1953.

————. *Delaware's Buried Past*. New Brunswick, NJ: Rutgers University Press, 1968.

White, Dudley. *The Lighthouse*. Boston: New York Graphic Society, 1975.

Wildt, Chris. Cartoon in "Native Names." *Delaware Conservationist* (Winter 1988).

Williams, William H. *The First State: An Illustrated History of Delaware*. Northridge, NC: Windsor Publishing, 1926.